# PRISCILLA HAUSER'S BOOK OF ROSES

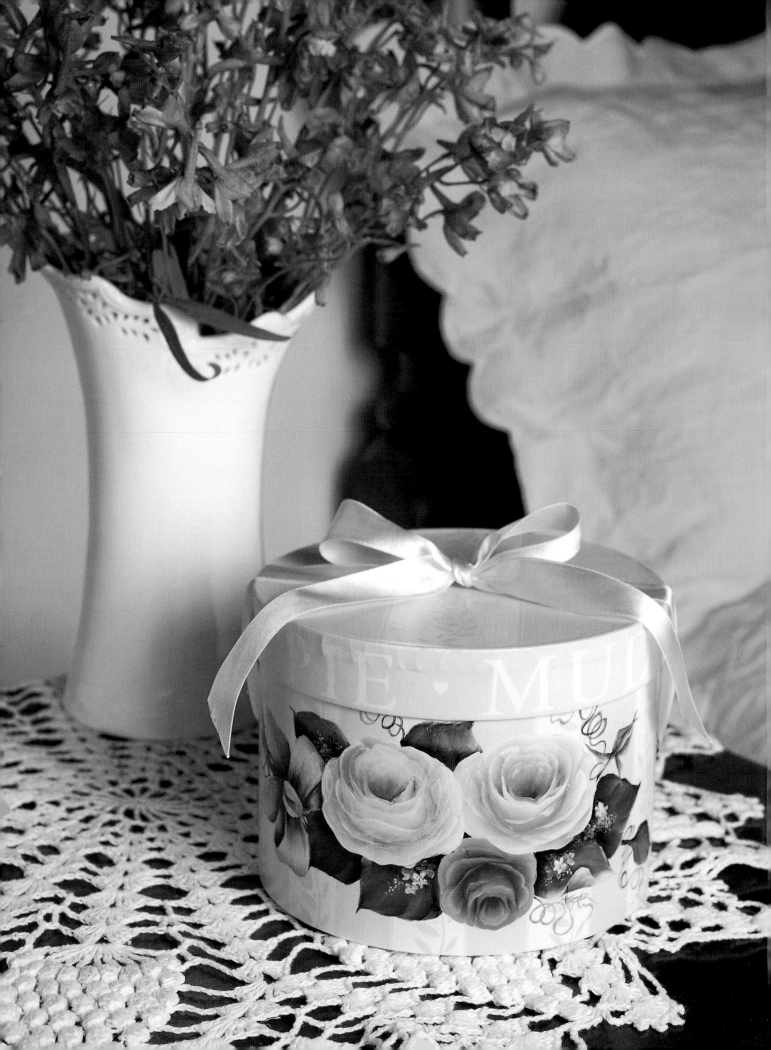

# PRISCILLA HAUSER'S

# BOOK *of* ROSES

**NORTH LIGHT BOOKS**
CINCINNATI, OHIO

www.artistsnetwork.com

# dedication

*This book is dedicated to my friend, Carol Duvall. Through many years of television, she has introduced hobbies and crafts to hundreds of thousands of devoted fans. Her friendship and dedication to me and to decorative painting has enabled multitudes of people to discover they really can paint. Carol, may your life always be filled with roses!*

**Priscilla Hauser's Book of Roses.** Copyright © 2003 by Priscilla Hauser. Manufactured in China. All rights reserved. The patterns and drawings in this book are for the personal use of the decorative painter. By permission of the author and publisher, they may be either hand-traced or photocopied to make single copies, but under no circumstances may they be resold or republished. No part of the text, patterns, paintings or instructions, whether in whole or in part, may be used for profit or reproduced in any form, except as noted above, without the express written permission of the copyright holder. No other part of this book may be reproduced in any form or by any electronic or mechanical means including information storage and retrieval systems without permission in writing from the publisher, except by a reviewer, who may quote brief passages in a review. The content of this book has been thoroughly reviewed for accuracy. However, the author and publisher disclaim any liability for any damages, losses or injuries that may result from the use or misuse of any product or information presented herein. It is the purchaser's responsibility to read and follow all instructions and warnings on all product labels. Published by North Light Books, an imprint of F&W Publications, Inc., 4700 E. Galbraith Rd., Cincinnati, Ohio, 45236. (800) 448-0915. First edition.

07  06  05  04  03        5  4  3  2  1

**Library of Congress Cataloging-in-Publication Data**
Hauser, Priscilla.
    Priscilla Hauser's book of roses / Priscilla Hauser.
        p. cm.
    Includes index.
    ISBN 1-58180-306-0 (pbk. : alk. paper) -- ISBN 1-58180-308-7 (alk. paper)
    1. Painting--Technique. 2. Roses in art. I. Title: Book of roses. II. Title.
TT385 .H377 2003
745.7'23--dc21                  2002038056

## METRIC CONVERSION CHART

| TO CONVERT | TO | MULTIPLY BY |
| --- | --- | --- |
| Inches | Centimeters | 2.54 |
| Centimeters | Inches | 0.4 |
| Feet | Centimeters | 30.5 |
| Centimeters | Feet | 0.03 |
| Yards | Meters | 0.9 |
| Meters | Yards | 1.1 |
| Sq. Inches | Sq. Centimeters | 6.45 |
| Sq. Centimeters | Sq. Inches | 0.16 |
| Sq. Feet | Sq. Meters | 0.09 |
| Sq. Meters | Sq. Feet | 10.8 |
| Sq. Yards | Sq. Meters | 0.8 |
| Sq. Meters | Sq. Yards | 1.2 |
| Pounds | Kilograms | 0.45 |
| Kilograms | Pounds | 2.2 |
| Ounces | Grams | 28.4 |
| Grams | Ounces | 0.04 |

EDITOR: Maureen Mahany Berger
DESIGNER: Brian Roeth
PAGE LAYOUT ARTIST: John Langan
PRODUCTION COORDINATOR: Kristen Heller
PHOTOGRAPHERS: Christine Polomsky and Tim Grondin

# About the Author

PRISCILLA HAUSER WITH
CAROL DUVALL

Priscilla will teach you to paint roses. Along with that, she will fill your life with roses. Priscilla has been married to her true love, Jerry Hauser, for more than forty years and is the mother of four gorgeous young adults and is grand-mother to the most adorable little ones in the world. Priscilla's boundless energy continues to thrive. She has taught thousands the joy of decorative painting in her charming *Studio by the Sea*, located on the outskirts of Panama City Beach, Florida. Priscilla and Jerry divide their time between Florida and Tulsa, Oklahoma.

She is a regular guest on the *Carol Duvall Show* where she lovingly teases the adorable Carol Duvall, HGTV's Crafting Queen. She has also had the pleasure of appearing on the *Christopher Lowell Show* and *Home Matters* with Susan Powell.

Famous for painting fruits and flowers, Priscilla's trademark is roses. "Roses speak in so many ways," says Priscilla. "They speak of love, sympathy, happiness and sadness. Their colors create an incredible rainbow. They are just plain wonderful."

Yes, anyone who really wants to can paint a rose. Yes, you have to practice. Yes, it is exciting. Yes, yes, yes—there are no negatives at all!

"You can do it, you can do it, you can do it!" shouts Priscilla to a student learning to paint a rose. "Double load that brush, blend on your palette, be sure the consistency is right, be sure the brush is full. Now, put those strokes together. It's like building a beautiful house brick by brick: stroke by stroke, you build that rose. Over and over again, many times over, practice painting those roses and you'll have it!" That's what it sounds like in a seminar with Priscilla Hauser. This energetic blonde has been teaching painting for more than forty years. Flowers, fruit, birds—you name it—but she is best known for her roses. Big, beautiful, flowing roses in every color imaginable. To watch her paint them is magical, and she loves to show you how.

Let Priscilla guide you, brush in hand, step by step through the pages of this book. Read, study carefully, follow the directions, and the magic of painting roses will be yours.

## ACKNOWLEDGMENTS

Without Naomi Meeks, Sue Sensintaffar, Judy Kimball and Connie Deen this book would not exist. Naomi diligently worked at my side doing much of the preparation for the beautiful photos contained within; Sue worked with me daily on the manuscript; Connie wore out the keyboard on the computer; and Judy inked the designs.

In addition, I want to thank my photographer, Christine Polomsky, who climbed to the sky, stood on her head, and did everything possible to get the correct camera angles in order to create these photos.

Last, but not least, I want to acknowledge my wonderful editors at North Light Books, Maureen Mahany Berger and Kathy Kipp.

# TABLE OF
# *contents*

INTRODUCTION
page 8

GLOSSARY
page 10

RESOURCES
page 142

INDEX
page 143

CHAPTER ONE
## Supplies
page 12

CHAPTER TWO
## Surface Preparation &
## Finishing Techniques
page 17

CHAPTER THREE
## Six Basic Painting Skills
page 21

CHAPTER FOUR
## Building a Rose
page 31

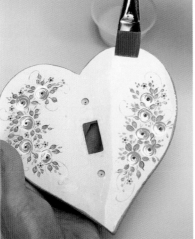

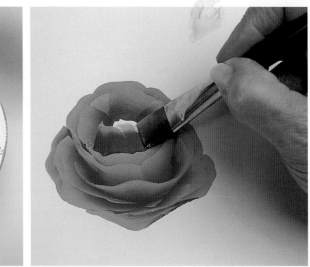

# Projects

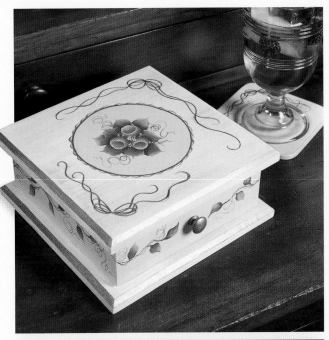

*one* | LIGHT UP WITH ROSES
page 60

*two* | WINE & ROSES
page 68

*three* | MIDNIGHT & ROSES
page 76

*four* | MAGICAL TIME FOR ROSES
page 82

*five* | SILKEN ROSES
page 94

*six* | A BEAUTIFUL GIFT
page 100

*seven* | AUNT KATHY'S HATBOX
page 108

*eight* | LESLIE'S WEDDING TRUNK
page 116

*nine* | ROSES ARE RED
page 126

*ten* | GARDEN ANGEL
page 134

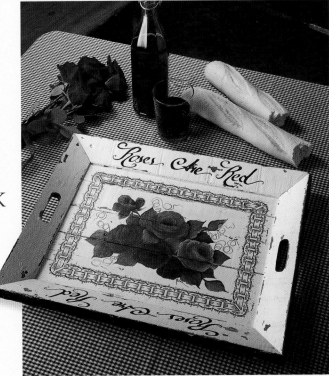

# ❈ I N T R O D U C T I O N ❈

WHEN I WAS A VERY LITTLE GIRL, I LOVED WATCHING MY
grandmother take cuttings from rose bushes in her yard. She would
cut in just the right place, pack the cut area with a mixture of bone
meal and water, wrap it in a tissue, tie it with a thread, place it in the
ground and cover it with a Mason jar. When spring came and the jar
was removed, much to my delight, a tiny little rose bush was born.
My grandmother's last name was Langworthy. Her family was Eng-
lish. I never asked her, but I assume much of her knowledge of roses
came from that heritage.

I haven't tried to make a cutting grow into a bush (it is something
I intend to do someday), but I did learn to paint and teach others to

paint roses. I was as proud of the
very first roses I painted as I am
of the ones I paint today. My first
roses were very dramatic. I chose
a monochromatic color scheme
and painted brown roses on a
brown saltshaker. They looked
like horse droppings in flying let-
tuce leaves. I've never had a stu-
dent paint roses as badly as those
first roses of mine. I hope sharing
this information with you will
give you the encouragement you
need to get started painting roses.

Priscilla's first roses

8

# Encouragement from Priscilla

Roses, roses, roses—yes, you can paint them, and you can paint them beautifully! However, you must practice; you must learn the skills (brushstrokes, double loading, proper paint consistency, how to fill a brush, how to blend on a palette, how to gradate the colors on the brush from dark to medium to light, how to control values). All of these skills must be learned, and then, with practice, you will build your rose.

Once you know how to paint roses, leaves and buds, you can paint them with any kind of paint (oils, acrylics, watercolor) — it is just a matter of learning how the particular type of paint works.

Discouragement is rarely part of my world. I know I can do anything I want, and I know you can paint roses if you truly want to. I've made it easy for you to learn, but I cannot practice for you. That is something only you can do. Take a dry brush and stroke over my worksheets many, many times. Then fill that brush with paint and go for it! Soon, your roses will be blooming beautifully.

If you will paint a hundred roses, they will bloom from your brush for the rest of your life. What fun they are to create! Please read the instructions carefully, following them step by step, and the magic of roses will be yours.

*Priscilla Hauser*

# Glossary

**ANCHOR** | If I throw an anchor over the side of a boat, hopefully the boat won't move. In decorative painting, if I float an anchor in the shadow or highlight area of a design (such as a shadow at the base of a leaf), let it dry, and then come back to paint the design, the dried anchor won't move. It's extremely helpful—particularly when blending—to anchor shadows and occasionally, highlights. When you put a blending gel and your colors back down on the undercoated anchored surface, the anchors stay put when you blend.

**ARTISTS' ACRYLICS** | These are fine artists' tube acrylics (pure in pigment) found in art and craft stores. Plaid manufactures a brand called *Artists' Pigments* that come in squeeze bottles with gold-colored lids.

**BACKGROUND COLOR** | The application of color around the edge of a design, usually applied after the pattern is transferred but before the design is painted. Occasionally, the background color is carefully applied after the design is painted.

**BASECOATING** | To paint a piece of wood, tin or other surface with two or three coats of paint before decorative painting is done, or to paint only the actual design area. This should always be applied as smoothly and evenly as possible.

**BLENDING** | The merging or combining of two or more colors. It is usually done with a flat brush.

**BRUSHSTROKES** | A series of strokes, such as the comma and S-stroke, which are practiced and perfected until they can be performed uniformly. These are the alphabet of decorative painting.

**BURNISHING** | To rub or polish. This method is used in this book to rub and smooth gold leaf after the leaf has been applied to the surface and allowed to sit overnight.

**COLOR WASH** | This is an application of thin paint (thinned with water or other medium) that is applied over an inked design or a painted surface to add a blush of color.

**CRAFT PAINTS** | Any of the bottled acrylics in premixed colors found in art, craft or hardware stores.

**CURING** | When something is dry only to the touch, it is not cured. If something is cured, it is dry all the way through. If you fall down and skin your knee and it bleeds, it is wet. When a scab forms, it is dry. When the new skin grows, it is cured. I am frequently asked how long it takes to cure a painted piece. There is no right answer. It depends upon the temperature, air circulation, humidity, paint colors used, and thinness or thickness of the paint. When a piece is cured, it feels warm and dry. It could take three hours, or it could take three weeks.

**DOUBLE LOADING** | To carry two colors side by side on a brush. Where the two colors meet, they should blend together gradually.

**DRYING** | This occurs when the paint is dry to the touch. Being dry is not the same as being cured.

**FLOATING** | A technique in which the brush is filled with blending medium or water on one side, and paint on the other. It is used to create shadows and highlights.

**GLAZING** | This is the application of thinned pigment on top of an undercoated or painted design. One of the differences between the color wash and glazing techniques is that a wash is usually just one coat. When you glaze, many coats may be applied on top of each other.

**MEDIUM** | A liquid used in painting to achieve a desired effect. Mediums include water, glazing medium, blending gel and floating medium. Generally, they are of different consistencies and perform different tasks.

**OUTLINING** | Outlining is optional. To outline, you may use a pen or a brush. To use a brush, fill an excellent liner brush with paint that has a thin, ink-like consistency (thin the paint with water).

**PAINT CONSISTENCY** | This refers to the thinness or thickness of the paint. Different techniques require different paint consistencies.

**ROSE BOWL** | This pertains to the "cup" or base of the rose.

**SHELL OF THE ROSE** | This pertains to the first thirteen strokes of the painted rose.

**SIZING** | In this book, sizing refers to the glue used underneath gold leafing.

**SKILLS** | These are the basics of painting. They consist of brushstrokes, blending, floating, double loading, knowing how to fill a brush and knowing the proper paint consistency. Skills must be learned and practiced before techniques are used.

**TECHNIQUE** | The method for painting something, such as a leaf or a rose. A technique consists of many skills.

**UNDERCOATING** | This is the process of neatly and carefully applying paint (generally a craft paint) as a base color for a leaf, flower or portion of a design. Sometimes undercoating is done on the entire project. Often one application of craft paint does not cover adequately, and it will take multiple applications to achieve the desired result. You must let the paint dry between each coat.

**VALUE** | The lightness or darkness of a color. There can be many values of any one color.

CHAPTER

1

# SUPPLIES

## GENERAL SUPPLIES

These are the supplies I use when I paint:

- Pencil
- Masking tape
- Soft, absorbent 100% cotton towels or rags
- Wet towelettes
- Dry or utility palette
- Scotch Magic Tape
- Styrofoam plates
- Plastic wrap
- Palette knife
- Petit fours (small, square sponges) for basecoating and creating stripes and borders
- Plaid Stencil Decor Daubers
- Foam brushes

- Masterson Sta-Wet Palette
- Tracing paper and stylus for transferring patterns
- Black and white graphite paper
- White chalk pencil
- Cheesecloth for applying stain
- Brown paper bag for very light sanding
- Paper towels
- Brush basin
- Brush cleaner
- Toothbrush for spattering
- Clear acrylic spray, matte

Some people may prefer to use a dry or wax-coated palette for acrylics. In most cases I prefer to use the Masterson Sta-Wet Palette to keep my paints from drying too quickly. The Masterson palette consists of a plastic tray that holds a wet sponge. The special paper that is included should be soaked in water for 24 hours, then placed on the wet sponge. Blot the paper with a soft, absorbent rag to remove excess water. When your acrylics are placed on the properly prepared palette they will stay moist for a long period of time.

## PAINT

FolkArt Artists' Pigments are superior-quality fine artists' acrylics in squeeze bottles. Because Artists' Pigments are of a thicker consistency, the opening on the lid is larger than most acrylic paints.

Regular FolkArt Acrylics are more like paint for your walls. The quality is excellent and I use them often for basecoating, undercoating and occasionally for the project itself.

Artists' Pigments have a different chemical formulation and are slower to dry and cure than the regular FolkArt Acrylics. This is why I often undercoat with the FolkArt Acrylics and then use the Artists' Pigments for the decorative painting.

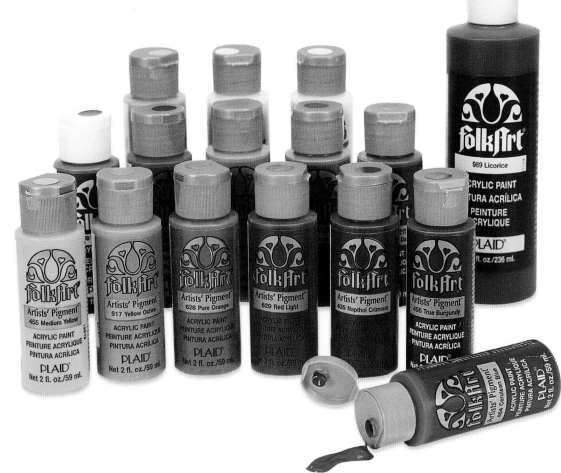

## BRUSHES

Please invest in the best brushes you can afford. You'll need synthetic brushes for acrylic painting. My favorite brushes are Loew-Cornell Golden Taklon series 7300 flats, series 7200 rounds and series 7500 filberts.

The size of the brush you choose will depend upon the size of the area you are painting. Small designs require small brushes. Large designs require large brushes. Using the proper type of brush is essential for decorative painting.

Flat brushes are used for stroke-work and for blending color. Round brushes are traditional stroke brushes. Liner brushes are used for lines and details. Mop brushes are used for finishing touches and smoothing when blending.

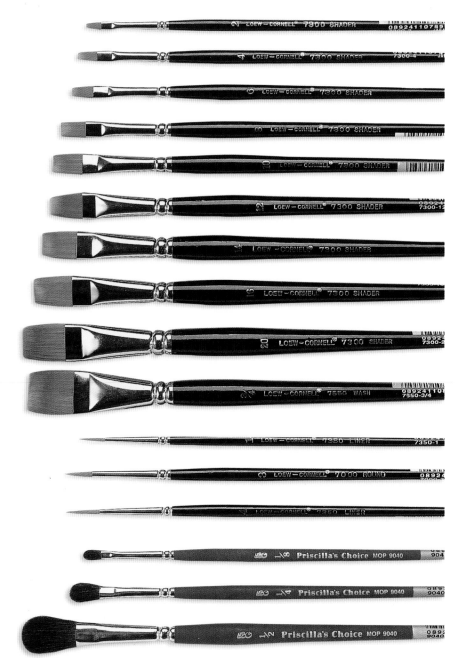

## CARING FOR YOUR BRUSHES

After you finish painting for the day, wash the brush in brush cleaner. Be careful not to damage the hairs.

Work the brush back and forth in the cleaner to remove all the paint and pigment from the brush. Wipe it on a soft, absorbent paper towel.

Leave the cleaner in the brush and shape the brush with your fingers. Next time you want to use the brush, rinse it in water.

# SURFACE PREPARATION & FINISHING

**FOLKART GLAZING MEDIUM:** This medium is mixed with paint to make the paint more transparent. You can create stains, glazes that go over other colors, and many faux finishes.

**FOLKART FLOATING MEDIUM:** This medium simplifies the floating technique. It is easier to float a color with paint and floating medium than with paint and water. The floating medium is thicker than water and does not allow the paint to travel completely across the brush, giving you a nice gradation of color.

**FOLKART BLENDING GEL MEDIUM:** This medium makes blending acrylics much easier by keeping your paints moist and giving you more time to blend colors together.

**FOLKART GLASS & TILE PAINTING MEDIUM:** This medium gives tooth to a non-porous surface, increasing the durability of the paint on glass, tile and tin.

**FOLKART CRACKLE MEDIUM AND EGGSHELL CRACKLE:** The crackle medium produces large cracks and the eggshell crackle produces fine, cracked-porcelain-like cracks.

**SURFACE PREPARATION MATERIALS:**
- Sandpaper or a sanding disc in several grits
- Wood filler for nail holes and rough areas
- Rubber gloves (optional)
- Tack rag for wiping dust

**SEALER:** Water-based varnishes will finish and protect your project. All are brushed on and dry quickly. They are available in matte, satin and gloss finishes.

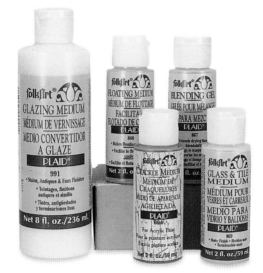

# Palette

When painting, I work with two different palettes. One is a wax-coated or dry palette. This could be as simple as a piece of wax paper. The other is the Masterson Sta-Wet Palette. This fabulous piece of equipment keeps my paints wet and flowing.

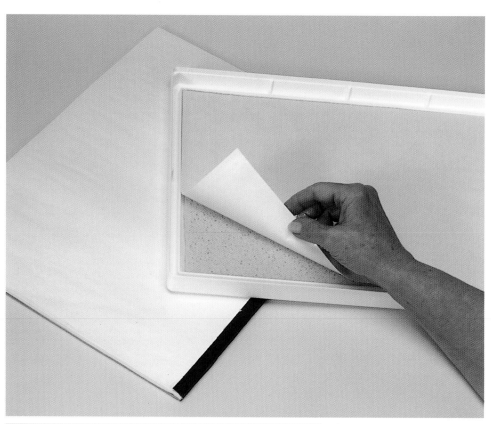

The Masterson Sta-Wet Palette.

## HINT

*A fast way to prepare the paper is to boil the paper in a glass dish of water in the microwave for five minutes. This will force the paper fibers to become very wet.*

When preparing the wet palette, it is important to soak the paper that comes with the palette for several hours before using it. Remember to always apply plenty of water to the sponge, so your hand gets very wet when it touches the top of the sponge. Finally, smooth the paper out on the sponge and wipe it dry with a cotton rag or soft, absorbent paper towels.

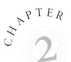

# SURFACE PREPARATION & FINISHING TECHNIQUES

## *Preparation of a Wood Surface*

Some people seal the wood before applying a basecoat of paint. I do so only when needed. For example, if the wood is green or has knotholes or discolorations, I would seal it lightly. I also recommend applying a light seal before applying the basecoat to a large piece of wood to prevent warping. If wood is tightly sealed and sanded, the basecoat of paint does not adhere as well as it does to unsealed wood. Once you finish your decorative painting and varnish it, it will be completely sealed.

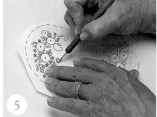

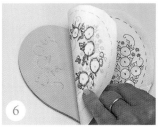

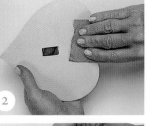

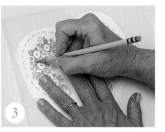

**STEP ONE**
Apply a smooth, even coat of paint with a foam brush. Let dry. Sand lightly and wipe with a tack rag. Apply a second and third coat if needed to cover.

**STEP TWO**
Rub with a piece of brown paper bag with no printing on it to smooth the nap of the wood. Wipe with a tack rag.

**STEP THREE**
Neatly trace the design. I recommend using a pencil on a sheet of tracing paper.

**STEP FOUR**
Turn the design over and go over the lines with a piece of chalk that contrasts with the basecoat color. Don't scribble with the chalk.

**STEP FIVE**
Position the design on the basecoated piece. Using a stylus, retrace the pattern lines.

**STEP SIX**
If properly done, the lines will neatly transfer to the prepared surface and will be easy to remove.

## HINT

❁ *I believe in making the transfer as easy as possible for students. Chalk is the preferred method because the lines can be removed easily. If you do not see well, go ahead and use gray or white graphite to transfer.*

❁ *If you are using a new sheet of gray graphite paper, wipe it with a soft rag to remove some of the carbon before using it to transfer the design.*

# Surfaces Other Than Wood

## PREPARING FABRIC

Preparation of fabric for decorative painting is relatively easy.

1. First wash the fabric, if possible, to remove any sizing from it. If the item you are going to paint will never be washed after you add your design, this step isn't necessary.

2. Neatly transfer your design. My favorite method for transferring a pattern onto fabric is to use chalk—white for dark fabrics and colored chalk for light fabrics. Charcoal pencils will also work well. Neatly trace the pattern onto tracing paper, turn it over and firmly go over the back of the lines with chalk. Shake off the excess chalk dust. Center the pattern on the fabric and hold it in place. Then scrape a plastic credit card across the pattern using a great deal of pressure. This will press the chalked pattern onto the fabric.

3. If you are using a loose piece of fabric, firmly attach it to a piece of foamcore board that has been cut to the appropriate size. To prevent spills and stray marks from spoiling the rest of the fabric, place the whole project in a plastic bag. Now cut out a window over the area to which the decorative painting will be applied and tape the edges of the plastic down.

4. You are now ready to add your decorative painting. I rarely use fabric mediums (paints, markers, etc.) when I paint on fabric. I simply mix my oils or acrylics to the proper consistency.

5. **FOR ACRYLICS**—Apply a little blending medium to the fabric. Be careful not to get too close to the edges of the design in order to avoid paint bleeding outside the design

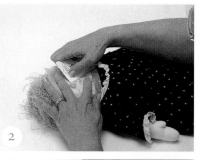

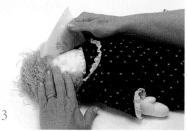

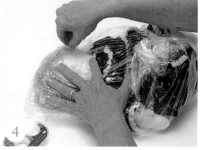

**STEP ONE**
Trace the pattern on to tracing paper, then go over the back of the design with chalk.

**STEP TWO**
Hold the pattern in place, chalk side down, and scrape over it with a credit card.

**STEP THREE**
The chalk pattern is transferred to the fabric.

**STEP FOUR**
Put the entire piece into a plastic bag to protect it, cut a window over the area you will be painting, and tape the edges down.

area. As long as the fabric stays wet with medium, the acrylics will stay wet and allow you to paint and blend beautifully.

6. **FOR OILS**—Apply a little gel medium to the fabric. This medium is available wherever oil paints are sold. The gel medium fills any texture in the fabric, allowing the oil paint to flow onto the fabric beautifully.

7. When dry, heat set the oils. This is not necessary with acrylics. Dampen the dried fabric with white vinegar. This helps set any colors that might not be permanent. Lay a pressing cloth over the oils and iron the painted area. Hang to dry.

## HINT

*I believe hand-painted items should be hand-washed. Save machine washing for machine-made fabrics. If I have spent the time to do a beautiful job painting something, I don't want to destroy it by using a washer or dryer. However, the choice is yours.*

## PREPARING TIN

Before tole painting, you need to prepare your tin and metal pieces so that paint will adhere properly to them.

1. The first thing I do for old tin pieces is make a thin paste of dishwasher detergent and water. Cover the item with this paste and let it set for about thirty minutes. (Please wear rubber gloves when applying the paste as dishwasher detergent can take the skin right off your hands.)

2. When the detergent has had time to work, scrub the metal with a steel wool pad, rinse with water and dry thoroughly.

3. To remove any rust from old pieces, purchase a good rust remover from a quality paint store and follow the manufacturer's instructions.

4. Prior to painting, the metal must be properly primed. There are good primers on the market, but I prefer to take my tinware to an automobile body shop. These people are experts at making paint adhere to metal, and often when they are getting ready to put a primer on a car they will spray my metal pieces as well. Always be sure to find out what type of paint—lacquer base, oil base or acrylic base—can be used on top of the primer if your primer color is not going to be used as the basecoat.

5. Basecoat over the primer, if desired. Let dry, and add your decorative designs.

## PREPARING PAPER

Although paper doesn't require much preparation, it generally has to be sealed pretty well before decorative painting can be applied on it. I usually seal the paper using many light coats of clear acrylic spray. Occasionally, I will transfer my design to the paper and seal only the design area before doing the decorative painting.

# *Finishing Techniques*

## VARNISHING

There are many types of varnishes: water-based, polyurethane, oil-based and lacquer, and they come in satin, matte, or high-gloss finishes. In this book, I have used water-based varnishes in both satin and gloss finishes. The choice is yours.

Generally, I apply two coats of varnish, letting each dry before applying the next. Then I rub with a piece of brown paper bag with no printing on it, wipe with a tack cloth, and then apply a final coat. In a weak moment, when I want an especially gorgeous piece, I may apply two or three more coats, hand-rubbing with 4/0 steel wool and wiping with a tack cloth between each coat.

## APPLYING THE VARNISH

Both the varnish you're applying and the piece you're using should be at room temperature. Pour the varnish into a small container. Dip a soft-haired varnish brush into the varnish. Gently wipe it on the side of the container to remove any excess.

Let the varnish dry before applying a second or third coat. Let dry. Rub with a piece of brown paper bag with no printing on it to smooth the surface. Wipe with a tack cloth. Apply a final coat of varnish.

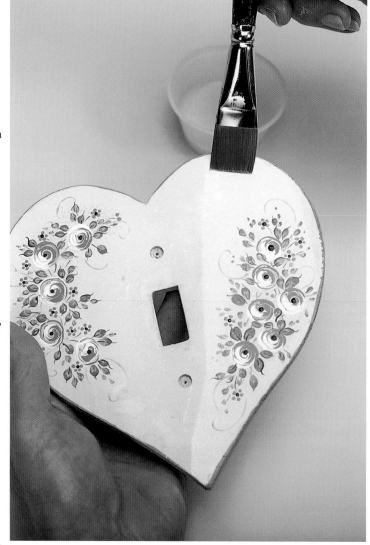

Allow the varnish to flow onto the finished piece.

## HINT

**QUESTION:** Do you ever spray a varnish on?

**ANSWER:** *I do, on occasion, although I prefer a brushed-on finish because*
1. *you get better coverage*
2. *it's environmentally safe*
3. *you don't need to worry about even coverage or runs.*

# SIX BASIC PAINTING SKILLS

I know how much you would like to sit down and paint a beautiful rose. You can do it, but please don't try until you have mastered the skills in this chapter. I'll make a deal with you. If you will practice and learn to use these skills, not only will you paint beautiful roses, you'll be able to paint anything you want. That's how important your skills are. To paint roses, you must know the basic brushstrokes and variations, proper paint consistency (a flowing consistency is essential for roses), double loading (carrying two colors on the brush at the same time), and how to blend on the palette so the two colors gradate through the hairs of the brush from dark to medium to light.

Good brushes in top condition are essential. So are knowing how to properly prepare the surface you are painting on, and controlling values (the amount of light and dark on the brush). Last, but not least, comes practice. How much practice? If you practice skills five days a week for one hour per day for three months before you practice building a rose (one a day for five days a week for three months), you'll have it. Does that sound like a lot? To me, it doesn't. I studied the piano for twelve years.

As you begin to paint, start with the open rosebud and then the basic roses. They will provide you with a little instant gratification—only, of course, after you have practiced the skills. The great reward comes when a rose blooms from the end of your paintbrush. When this happens for you, send me a picture and I'll celebrate with you.

## *Paint Consistency*

1

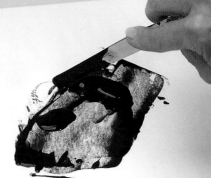

2

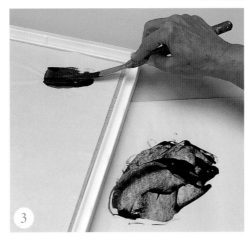

3

**STEP ONE**
Using acrylics, thin the paint with water on your dry palette until the paint is a flowing consistency.

**STEP TWO**
Flowing consistency is *everything*! Roses are built from brushstrokes. If the paint doesn't flow properly from your brush, you will not be able to paint roses.

**STEP THREE**
Move the thinned paint to the Sta-Wet palette with a palette knife. I am using True Burgundy.

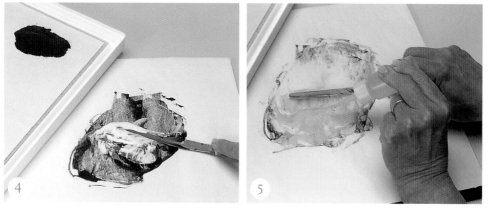

**STEP FOUR**

Mix a touch of True Burgundy with Warm White.

**STEP FIVE**

Add water to the mix until you have the proper consistency: maple syrup or thick, flowing cream. Transfer this to the wet palette.

# *Floating*

Floating enables you to create shadows or highlights. Floating is a skill that actually comes from the watercolor world. If you can double load your brush properly, you can float properly. Instead of using two colors on the brush, you will use one color and water or a floating medium. These mediums are manufactured by various companies. You can buy a product called *Floating Medium,* or you could use a glazing medium or a blending gel. Once you have really practiced and have the skill under control, I think you will prefer to float with water.

Floating enables you to create shadows or highlights.

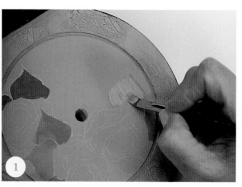

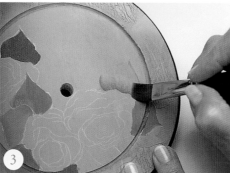

**STEP ONE**

Neatly undercoat the object using craft paint. Let dry and cure.

**STEP TWO**

Dampen with a little water.

**STEP THREE**

Double load as large a brush as you are comfortable using with water plus the shading color; blend on the palette until the paint gradates through the hairs of the brush from dark to medium to light. Float the shadow or highlight on the object.

# Blending

**STEP ONE**

Blending is combining two or more colors together wet-into-wet. When using acrylics, it is necessary to use an extender or retarder to keep the paint as wet as possible. I am using a blending gel. I prefer a gel consistency because it is not thin and runny and it is less likely to bleed.

Do not put the gel on the wet palette. Instead, squeeze the gel into a small container.

When blending, use as large a brush as possible. Apply a small amount of blending gel and wait 30 seconds for it to penetrate the surface.

**STEP TWO**

Apply the colors. Use lots of paint.

**STEP THREE**

Wipe the brush and practice blending the colors together.

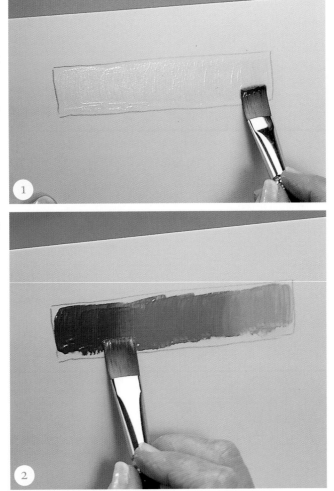

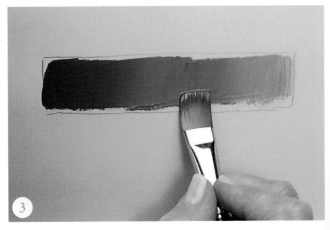

## HINTS

1. *When blending, use as large a brush as possible. You do not want a lot of tiny, choppy brushstrokes.*
2. *Use a very light touch. Don't bear down hard on the brush.*
3. *Use plenty of paint.*
4. *Work as quickly as possible.*
5. *The paint consistency should be like soft, spreadable butter or cake icing. If the paint is too thin, you will overblend and make mud.*
6. *When blending, always follow the natural curve or shape of the object you are painting.*
7. *You may add more gel or more paint as desired.*
8. *Stay away from water. Adding water will thin the paint and lift it from your surface.*

# *Basic Brush Strokes*

## FLAT BRUSHSTROKE—SINGLE COLOR

**STEP ONE**

For practice, I suggest using a no. 12 or a no. 14 flat brush in excellent condition. When practicing, put a piece of tape on the end of the handle of the brush to create a flag. This way, you can tell if you are twisting the brush in your fingers, which you do *not* want to do— except on the half-circle strokes.

**STEP TWO**

Dip the brush in water. Blot on a soft, absorbent 100% cotton rag or a very soft paper towel. Always use 100% cotton because nylon or polyester or cheap paper towels do not absorb and can be very destructive to your brush hairs. Fill your brush completely with paint.

**STEP THREE**

Basic stroke: Fill the brush with paint which has been thinned to a flowing consistency. Touch, apply pressure, hold the pressure and pull.

**STEP FOUR**

Line stroke: Stand the brush on the flat edge with the handle pointing straight up toward the ceiling, and slide.

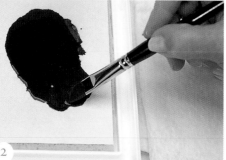

**STEP FIVE**

Comma stroke: Drawing a diagonal line will help you place the head of the stroke. Touch on the line, apply pressure on the flat surface, pull, and gradually lift.

**STEP SIX**

Drag and lift to a point.

**STEP SEVEN**

Reverse comma stroke: Reverse the direction.

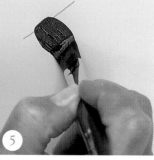

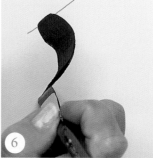

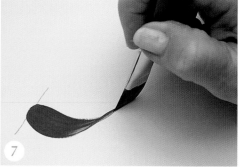

STEP EIGHT

S-stroke: Often it helps to draw a tulip shape, as shown. Stand the brush on the flat edge, angle slightly to the corner, and pull.

STEP NINE

Apply pressure and pull.

STEP TEN

Lift back up on the flat edge and drag.

STEP ELEVEN

Reverse S-stroke.

STEP TWELVE

Upside-down U-stroke: Stand the brush on the flat edge, slide up and gradually add pressure to the brush.

STEP THIRTEEN

Gradually lift, ending back on the flat edge of the brush.

STEP FOURTEEN

Right-side-up U-stroke.

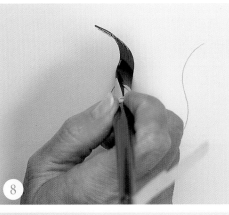

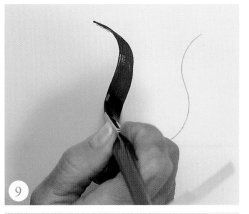

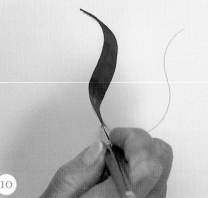

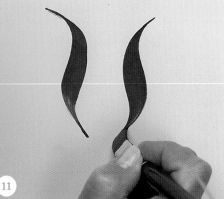

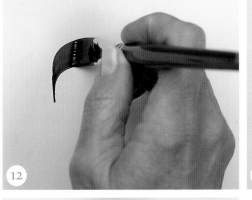

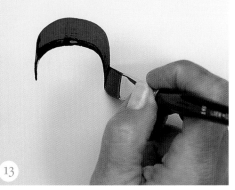

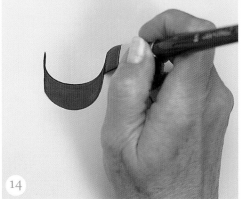

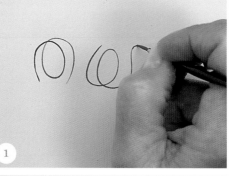

**STEP FIFTEEN**
Half circle: Touch on the flat edge of the brush, apply pressure to the flat surface, hold the pressure and pivot the brush in your fingers. The flag will wave.

**STEP SIXTEEN**
Continue to hold the pressure and complete the pivot.

**STEP SEVENTEEN**
Reverse half circle.

# *Liner Strokes*

Liners come in different sizes and lengths. Their ferrules (the metal part of the brush) are round; therefore, a liner is a member of the round-brush family. These brushes can be stroking brushes as well as lining brushes.

To do fine line work, fill the brush with paint which has been thinned with water to the consistency of ink. Twist the brush to a point and hold the brush so that the handle points straight up to the ceiling. Move the brush slowly and paint *M*'s and *W*'s. Then, connect the *M*'s and *W*'s.

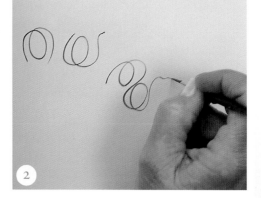

**STEP ONE**
Painting *M*'s and *W*'s.

**STEP TWO**
Connecting *M*'s and *W*'s.

# HINT

*"Be sure there is no water on the metal ferrule of the brush when using a liner. The water could run down onto the hairs and make a big blob on your line work."*

# *How to Double Load Your Brush*

**STEP ONE**

Stroke up against the edge of the lightest color first. Stroke approximately thirty times.

**STEP TWO**

Turn the brush over and stroke against the edge of the darker color. Stroke approximately fifteen times.

**STEP THREE**

Blend, blend, blend on one side of the brush.

**STEP FOUR**

Turn the brush over (keeping the dark color in the middle) and blend, blend, blend on the other side of the brush. Keep the dark color in the center and the light color to the outside.

**STEP FIVE**

Go back and pick up more light paint, stroking many times.

**STEP SIX**

Go back and pick up more dark paint, stroking many times.

**STEP SEVEN**

Return to the same spot on your palette where you are blending. Add more paint and blend until you see the color gradate beautifully through the hairs of your brush from dark to medium to light. Gradating color in the brush, as well as using plenty of paint of the proper consistency, will enable you to paint beautiful roses.

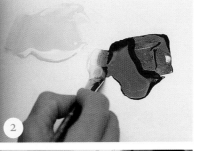

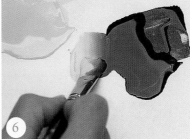

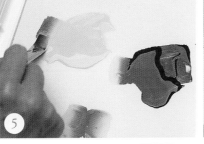

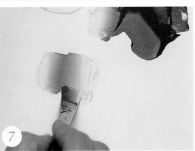

## HINTS

1. *Always use puddles of paint in proportion to the size of your brush.*

2. *It takes time and practice to develop this skill. Don't be discouraged. Pay attention to what you are doing. Practice filling the brush hundreds of times.*

3. *A matte-finished paper is so important when you double load. It creates the needed drag on the brush. A slick palette will not allow you to achieve good results.*

# Double-Loaded Brushstrokes

**STEP ONE**
Comma angled to the left.

**STEP TWO**
Comma angled to the right

**STEP THREE**
S-stroke angled to the left.

**STEP FOUR**
S-stroke angled to the right.

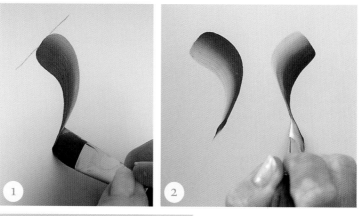

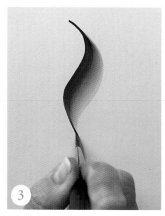

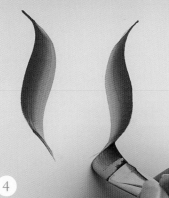

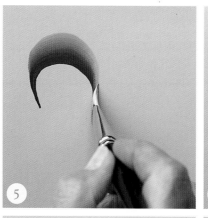

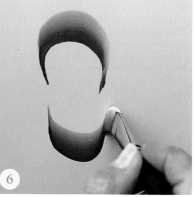

**STEP FIVE**
Upside-down U-stroke.

**STEP SIX**
Right-side-up U-stroke.

**STEP SEVEN**
Upside-down half circle.

**STEP EIGHT**
Right-side-up half circle.

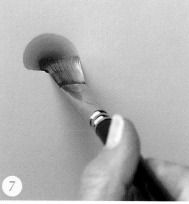

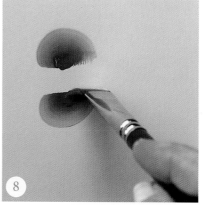

**STEP NINE**

Scalloped comma: These are used in forming the outside petals of roses. Touch, apply pressure, hold pressure and scallop.

**STEP TEN**

Lift to a point.

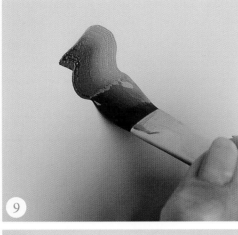

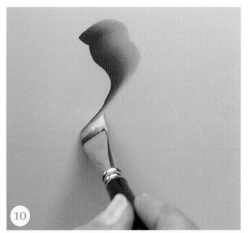

**STEP ELEVEN**

Reverse the stroke.

**STEP TWELVE**

Variation of an S-stroke: Touch on flat edge, slide, press and lift back to the flat edge and drag. This creates petal 13 when painting roses (see page 47).

**STEP THIRTEEN**

Broken U-stroke: Slide, press, and pick the brush up.

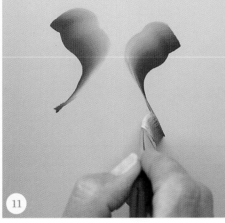

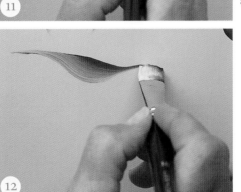

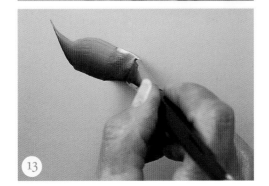

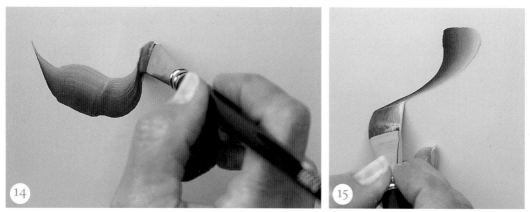

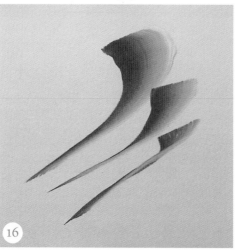

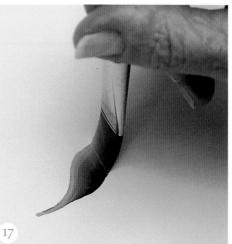

**STEP FOURTEEN**
Place the brush back down, pull and lift back on the flat edge of the brush. This stroke is often used to form the base or bowl of the rose.

**STEP FIFTEEN**
Slice: A narrow, double-loaded stroke. Slices form the edges of the petals and can be thick or thin.

**STEP SIXTEEN**
Double-strength slices in three different sizes.

**STEP SEVENTEEN**
Rolled S-stroke: This stroke creates a petal that cups up over the front of the rose. Slide and apply pressure.

**STEP EIGHTEEN**
Lift back up on the flat edge and drag.

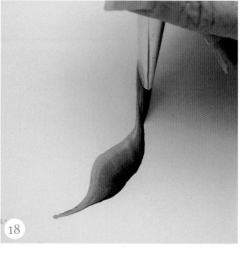

# 4 BUILDING A ROSE

Leaves are every painter's dilemma. They are shown with every flower, often with fruit, and certainly with roses. This particular leaf I call the Basic Brushstroke Drybrush Blend Leaf. It is a five-stroke leaf with colors added in the center. It is much like the basic black dress, in that the leaf can be dressed up or down.

There are many variations of it.

Work as diligently on developing your leaves as you do on developing your roses. The skills involved for painting leaves are the same as those for painting roses. Developing your skills will make you an incredible painter.

## Basic Brushstroke Drybrush Blend Leaf

STEP ONE
Using five brushstrokes, neatly undercoat your leaf with two or more coats of acrylic craft paint. Let this dry and cure.

STEP TWO
Using your skill of floating, float an anchor of Green Umber or your darkest shading color at the base or shadow area of the leaf. I used a large flat brush double-loaded with Green Umber on one side of the brush and water on the other side. Let dry and cure.

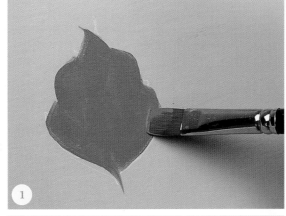

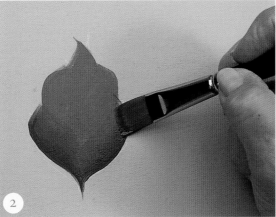

### HINT

*If you are painting on raw, unsealed wood, it is not necessary to undercoat the leaves before painting*

31

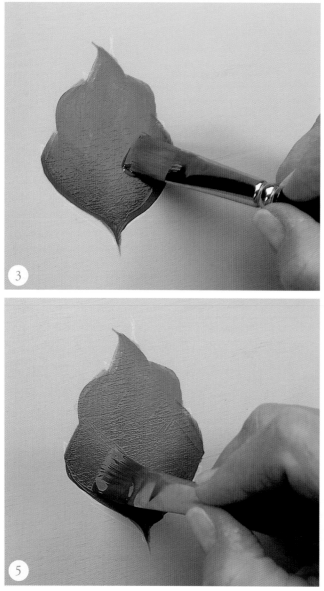

**STEP THREE**

Apply blending gel to the leaf.

**STEP FOUR**

Reapply the shadow color at the base of the leaf.

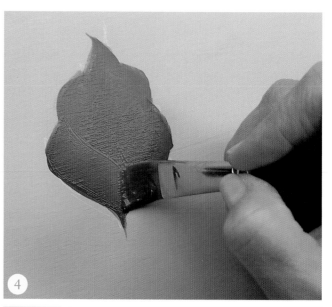

**STEP FIVE**

Double load your brush with Hauser Green Medium and Green Umber. Paint the first stroke into the shadow, starting at the outside edge and pulling toward the base.

**STEP SIX**

Apply the second stroke above the first stroke.

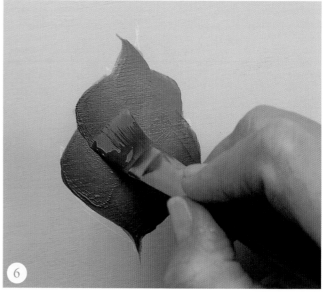

The next stroke is an incomplete S. Stand the brush on the flat edge with the dark side up, pull slightly and roll to the left.

### STEP EIGHT

Wipe your brush—don't clean it—and double load with Hauser Green Medium and Titanium White. Blend on your palette to soften the color. Apply stroke 4. Notice the angle. The strokes angle outward on the left side of the leaf, and they must angle outward on the right side of the leaf.

### STEP NINE

Apply stroke 5. Notice the placement of the white on the right side of the leaf.

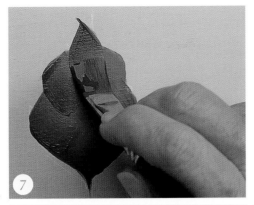

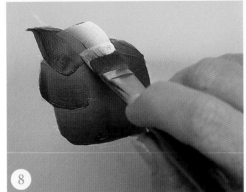

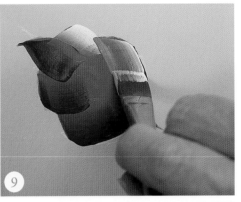

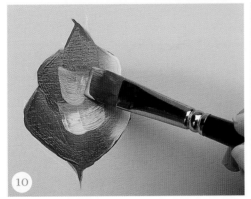

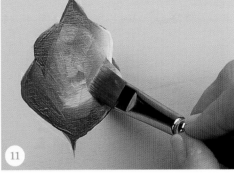

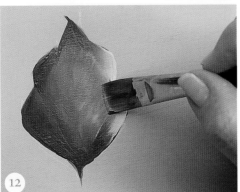

### STEP TEN

Add Yellow Medium and Hauser Green Light to the center of the leaf. Be generous with the amount of paint you use.

### STEP ELEVEN

Merge the colors together. Put half the brush on the edge of the colors you have just added and half on the leaf.

### STEP TWELVE

Directional blending: Blend using a light touch from the base of the leaf out into each of the five strokes.

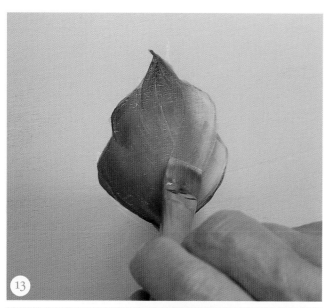

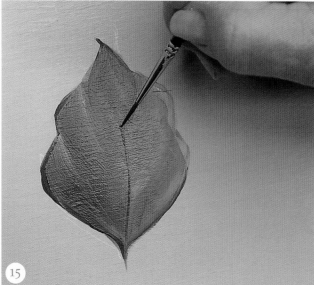

Using a light touch, pull from the outside edge back toward the base of the leaf.

STEP FOURTEEN
An accent stroke of white or Ice Blue may be added to the dark side of the leaf if needed.

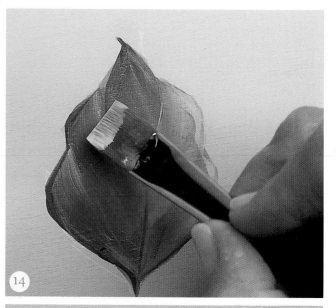

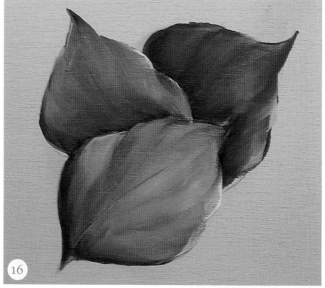

STEP FIFTEEN
To vein: Fill your liner brush with the darkest shading color used on the leaf. The paint should be thinned to an ink-like consistency. Paint a vein that curves with the shape of the leaf.

STEP SIXTEEN
A group of dark, medium and light value leaves. Notice on the lightest or top leaf that when two dark edges come together, I have used the high-light stroke on the dark side to create contrast.

# Turned Leaves

Leaves turn many different ways. This is just one example that is relatively simple to do.

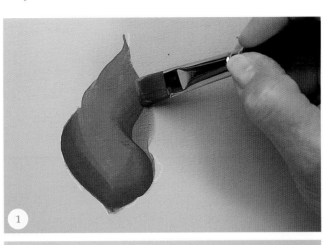

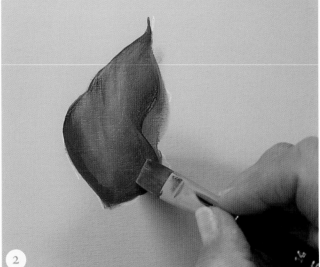

### STEP ONE

Undercoat the leaf with craft acrylics. Let dry. Anchor the shadows by floating with Green Umber and water. Let dry.

### STEP TWO

Apply blending gel. Double load the brush with Hauser Green Medium and Green Umber. Reapply the shadows.

### STEP THREE

The turned edge consists of three strokes. Please notice that I turned the leaf upside-down to paint the first stroke. Double load the brush with Hauser Green Medium and Titanium White. Paint the first stroke as shown.

### STEP FOUR

For the second stroke, I turned the leaf sideways and connected the corner of one white edge to the corner of the other.

### STEP FIVE

For the third stroke, I did the same.

### STEP SIX

Go back and add more blending gel and color if needed to the center of the leaf. Gently blend. Blend the turned edge neatly and carefully. A smaller brush may be used for blending that turned edge if desired. Break that smooth edge with a tiny accent stroke. Add a simple vein, if desired.

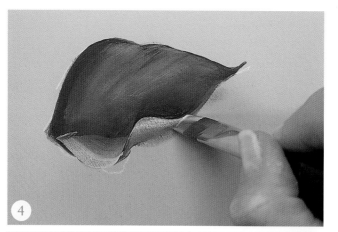

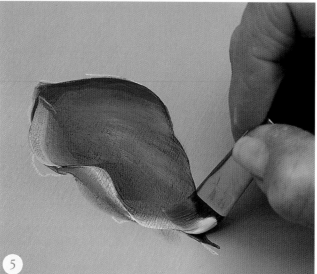

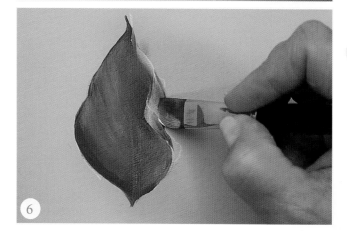

# HINTS

*Cut a leaf out of paper. Paint a dark side and a light side on the leaf cutout. Fold the paper in the same way you wish to turn the leaf. This will help you determine the color placement.*

# Border or Gel Leaf

You can use blending gel or glazing medium for this easy yet effective technique. The leaves can be painted in any combination of colors you wish. You may outline them or leave them as is.

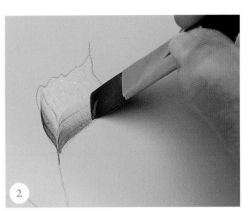

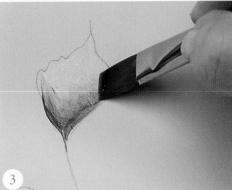

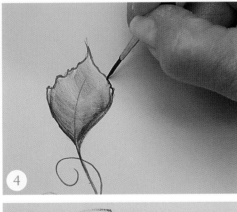

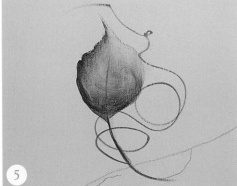

**STEP ONE**
Apply blending gel or glazing medium to the leaf.

**STEP TWO**
Double load the brush with blending gel and a little Burnt Sienna. Float this color at the base of the leaf.

**STEP THREE**
Pick up a little Green Umber and apply this to the shadow as shown.

**STEP FOUR**
While the blending gel is wet, blend the color out into the leaf. Keep the color light and thin—much like watercolor.

**STEP FIVE**
Using your no. 1 liner brush full of the Burnt Sienna and Green Umber mixture, neatly and loosely apply line work.

# The Basic Rose

I ask my students to paint one hundred—yes, *one hundred*—basic roses before ever trying the advanced rose. The basic rose builds your skills of brushstrokes, double loading, filling the brush and learning the proper paint consistency. Come on, *please*—I dare you to send me a bouquet of a hundred painted roses!

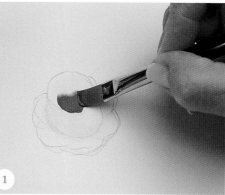

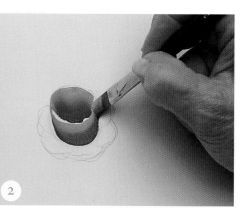

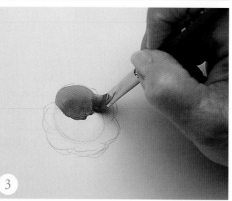

## HINTS

*Right-handed painters generally stroke from left to right. If you are left-handed, stroke right to left.*

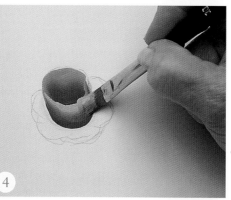

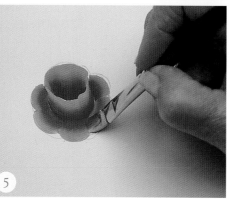

STEP ONE

Thin your paint to a flowing consistency. Apply a dot of color to the center of the rose.

STEP TWO

Double load your brush with the light and dark mixture. Blend on your palette to be sure the color graduates through the hairs of the brush from dark to medium to light. Paint an upside-down U-stroke around the dot of color, catching that color with the corner of your brush and allowing the color to blend right up through the petal.

STEP THREE

Paint a right-side-up U which connects to the tails of the upside-down U forming the bowl of the rose. You may go back over this as many times as you desire, as long as you go back over the whole stroke.

STEP FOUR

Carefully fill in the space under the center. To do this, pick up a little more paint and gently push the paint into the empty area.

STEP FIVE

Paint five quarter-sized (25mm) circle strokes around the bowl. It may be easier to use a smaller brush. I find it easier to paint strokes on alternating sides, but do what is comfortable for you.

# Rosebuds

Rosebuds, like the rose, are a combination of double-loaded brushstrokes, primarily U- and S-strokes. To paint them beautifully requires that your skills be fine-tuned. They are beautiful by themselves or used in concert with other rose designs.

## THE CLOSED ROSEBUD

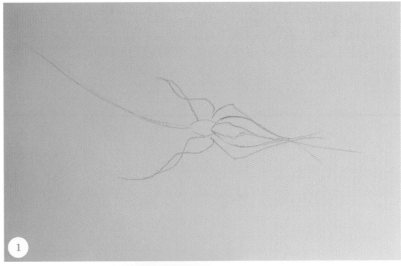

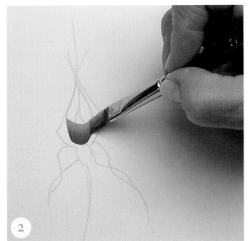

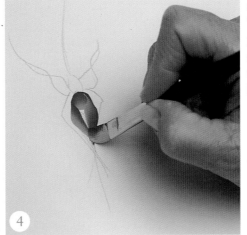

### STEP ONE
Transfer this rosebud pattern to your surface.

### STEP TWO
Double load your brush with a light and a dark color. Paint the U at the base of the bud.

### STEP THREE
On the left side of the bud, paint a variation of an S-stroke. Notice that the dark color is to the outside.

### STEP FOUR
Turn the bud upside-down and paint a variation of the S-stroke, pulling the brush toward you. Notice that the light color is to the outside.

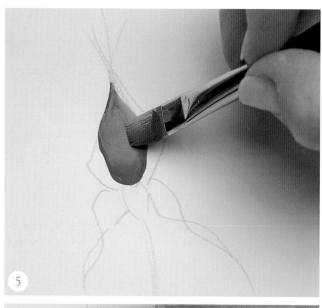

**STEP FIVE**

Blend the two strokes together in the middle.

**STEP SIX**

The calyx: Double load a small brush with Hauser Green Light and Green Umber. Paint five U-strokes to form the base of the calyx, as shown.

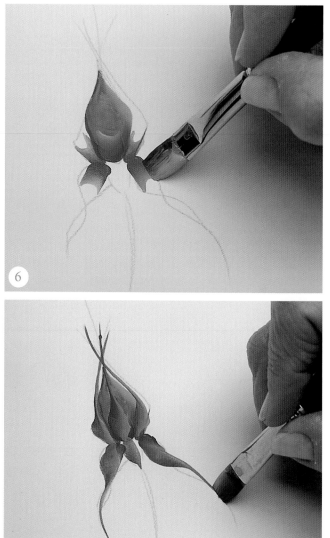

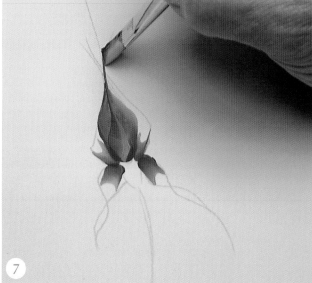

**STEP SEVEN**

Double load the brush with Hauser Green Light and Green Umber. Paint an S-stroke on the left or dark side of each of the U-strokes.

**STEP EIGHT**

Wipe the brush and double load with Hauser Green Light and Titanium White. Paint the light side of each bract. Please notice that I am on the flat or chisel edge of the brush, dragging as I complete the stroke. Blend where they meet in the middle.

**STEP NINE**
Finishing the bud.

**STEP TEN**
The stem: Paint and shade the stem with the liner brush. I prefer to double load my flat brush with Hauser Green Light and Green Umber. Stand the brush on its flat edge with the handle pointing straight up to the ceiling. Slowly paint the stem directly below the rose hip.

**STEP ELEVEN**
Highlight with a brush double loaded with Hauser Green Light and Titanium White.

**STEP TWELVE**
Go back and touch up any little empty spaces. Even out the color of the bud if needed.

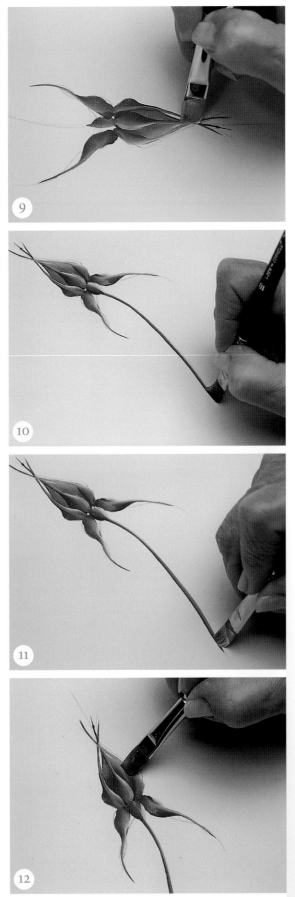

# HINTS

1. *Remember, buds are created using brushstrokes.*
2. *Your paint consistency must be thin and flowing.*
3. *Your double load must be very neat.*
4. *If the buds are small and you think you cannot see them, try using an Optivisor or a surgical loupe. Because I am extremely farsighted, I paint using an Optivisor (size 4 or 5) every day. It is a tremendous help. This extreme magnification does not hurt my eyes and makes painting tiny details a joy.*

## THE OPEN ROSEBUD

### STEP ONE
Transfer this pattern to a practice surface.

### STEP TWO
Apply a swath of color in the center of the bud.

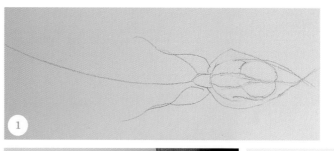

### STEP THREE
Double load the brush with a light and a dark color. Paint an upside-down U around the swath of color. Let the top of your brush slightly scallop as you paint the U, if desired.

### STEP FOUR
Paint a right-side-up U connecting the tails of the U to the tails of the upside-down U.

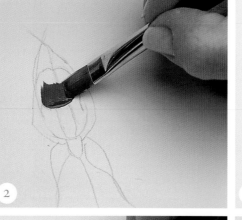

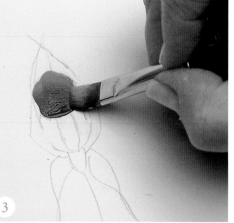

### STEP FIVE
Pick up more paint and carefully push the paint up into any empty spot that is under the center.

### STEP SIX
Paint the bracts and stem in the same way as instructed for the closed bud.

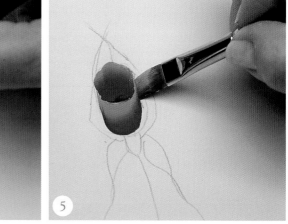

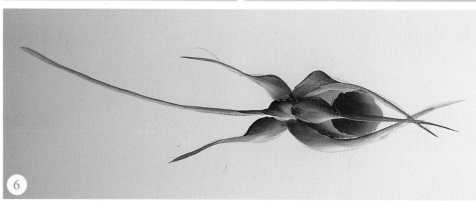

# Building a Rose

An advanced, open rose consists of twenty or more strokes. There is no certain number. Please, practice the first thirteen strokes until you can paint them relatively well. I call the first thirteen strokes the *shell*. Once you can paint those strokes, then continue on with the rest of the strokes. Please, don't even try to paint this rose until your skills are in excellent shape. What are the skills? Again, paint consistency (flowing), filling your brush full of paint, double loading the brush, and being able to paint brushstrokes and their variations very well. When you can do these things, you will be able to paint roses.

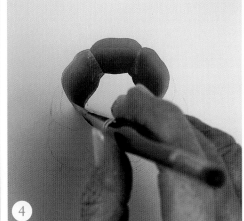

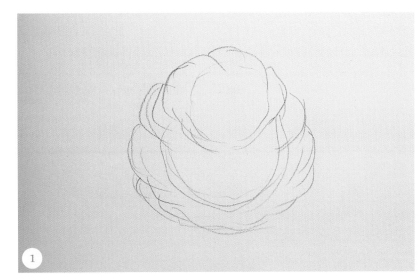

**STEP ONE**
Transfer this pattern to the practice surface.

**STEP TWO**
Double load the brush with a mixture of Titanium White and True Burgundy. Blend on the palette to soften the color. Be sure the paint is of a flowing consistency. Paint a scalloped stroke.

**STEP THREE**
Paint a scalloped comma.

**STEP FOUR**
Paint a scalloped comma on the left side. Be sure you have enough dark color so the next row of petals will show contrast against the dark.

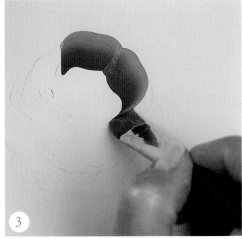

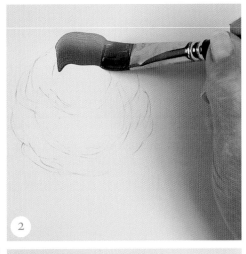

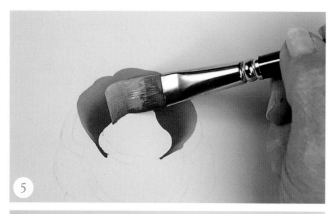

### STEP FIVE

Paint a quarter-circle stroke between petals 1 and 3.

### STEP SIX

Make a scalloped top stroke that falls between petals 1 and 2.

### STEP SEVEN

Stroke 6 is a scalloped comma.

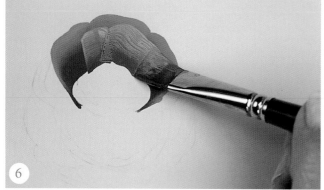

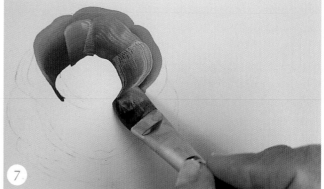

### STEP EIGHT

Stroke 7 is also a scalloped comma.

### STEP NINE

Please notice the four tails of the comma strokes. I'll call them A, B, C and D.

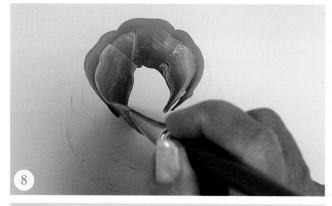

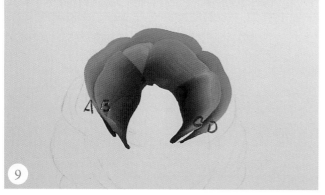

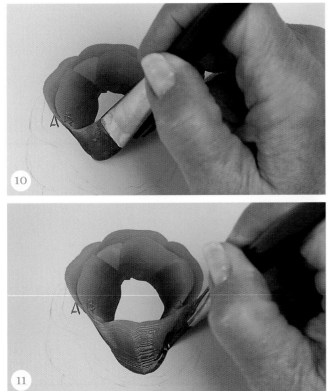

**10**

STEP TEN

Stroke 8 is a U-stroke that is a bit scalloped on the top. It connects the outside edge of tail B to the outside edge of tail C.

STEP ELEVEN

Connecting the U-stroke to tail C.

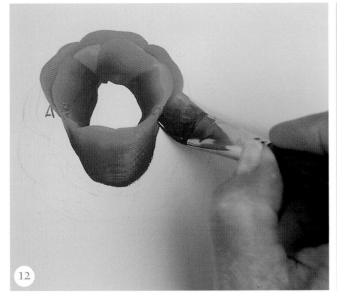

**11**

## THE OUTSIDE PETALS

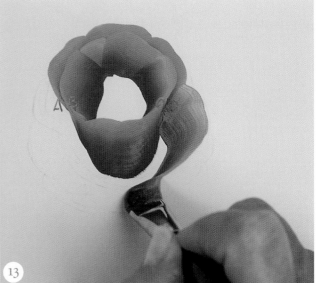

**12**

**13**

STEP TWELVE

Stroke 9 is a scalloped comma. Place the brush so it appears to come from behind stroke 2.

STEP THIRTEEN

Finishing stroke 9.

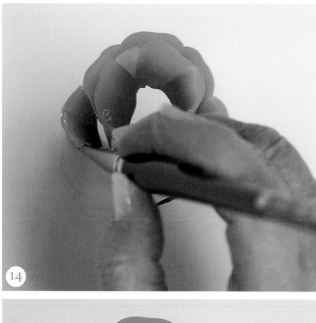

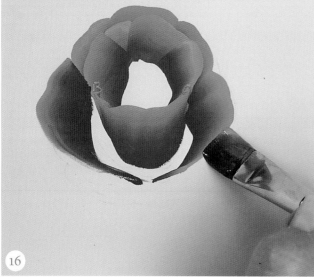

### STEP FOURTEEN
Stroke 10 is a scalloped comma. Place the brush so it appears to come from behind stroke 3.

### STEP FIFTEEN
Finishing stroke 10.

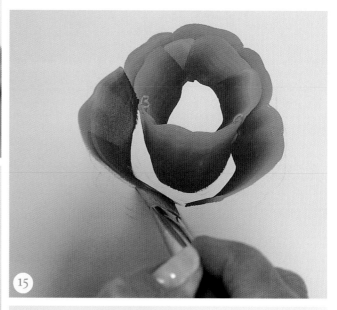

### STEP SIXTEEN
Stroke 11. Notice the placement of the brush.

### STEP SEVENTEEN
Finishing stroke 11.

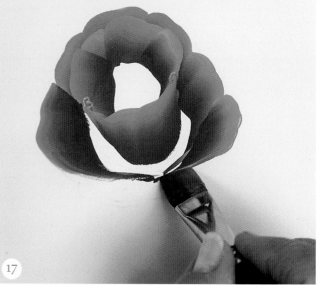

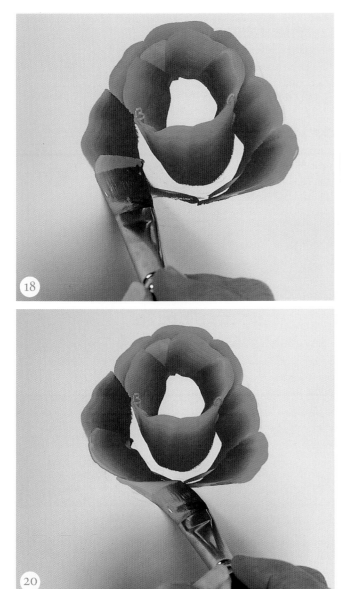

Stroke 12. Notice the place-
ment of the brush.

STEP NINETEEN
Finishing stroke 12.

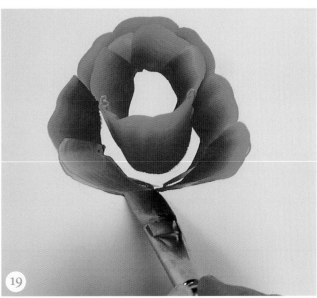

STEP TWENTY
Beginning stroke 13.

STEP TWENTY-ONE
Finishing stroke 13, which is a
variation of an S-stroke. Notice
that the light color is to the
outside.

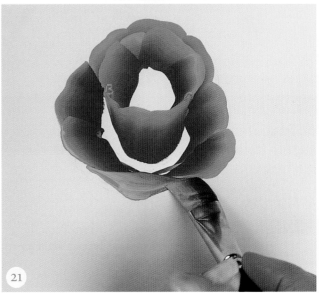

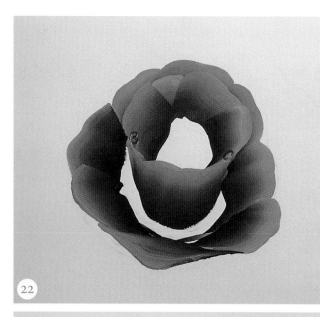

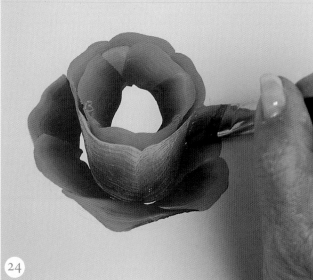

### STEP TWENTY-TWO
The finished shell. All thirteen strokes are now complete. This should be practiced many, many times before continuing to build the rose.

### STEP TWENTY-THREE
Stroke 14. This is a broken U-stroke that connects the outside edge of tail A to the outside edge of tail D.

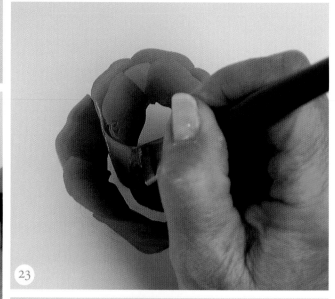

### STEP TWENTY-FOUR
Connecting to D.

### STEP TWENTY-FIVE
Stroke 15 is a smaller scalloped comma placed on top of stroke 9.

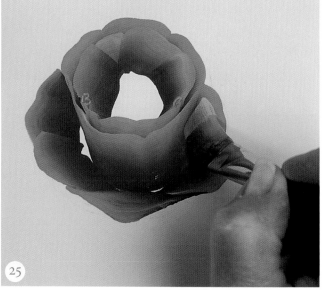

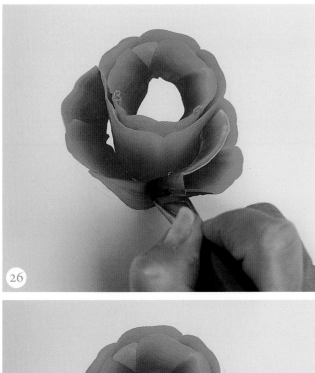

STEP TWENTY-SEVEN
Beginning stroke 16 on top of stroke 10.

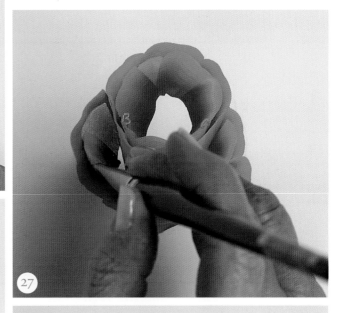

STEP TWENTY-EIGHT
Finishing stroke 16.

STEP TWENTY-NINE
Painting stroke 17 on top of stroke 11.

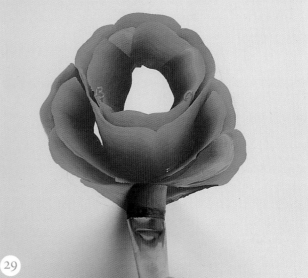

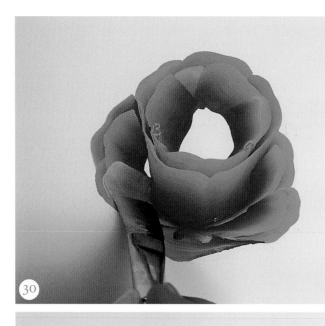

**STEP THIRTY**
Painting stroke 18 on top of stroke 12.

**STEP THIRTY-ONE**
Stroke 19. In this case, stroke 19 will reset stroke 14. This allows me to deepen the color in the bowl of the rose.

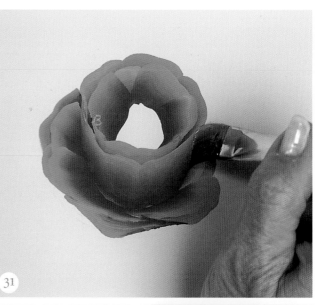

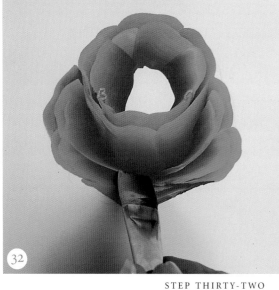

**STEP THIRTY-TWO**
Stroke 20 is a fill-in slice. These slices are very narrow comma strokes that represent the edges of the petal. Wherever your rose needs a fill-in petal, you should paint a slice.

**STEP THIRTY-THREE**
More slices.

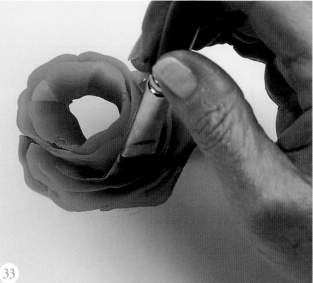

STEP THIRTY-FOUR

The beginning of the rolled S-stroke. This wonderful stroke cups a petal up over the bowl of the rose. It connects the tail of one little comma or slice to the tail of another on the other side of the bowl.

STEP THIRTY-FIVE

The rolled S in process.

STEP THIRTY-SIX

Finishing the rolled S and connecting to the tail of the comma on the other side of the bowl.

STEP THIRTY-SEVEN

If filler strokes are needed, add them at this time. This rose needs only one to finish it nicely.

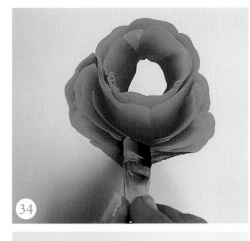

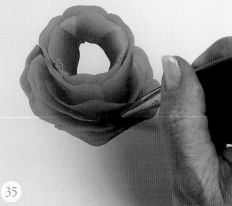

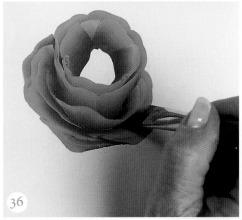

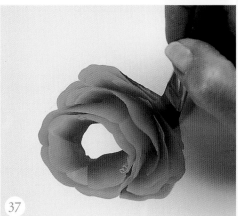

# HINTS

1. *Once you have mastered the strokes, the most beautiful roses are painted very fast—so you are painting wet-into-wet. This way, the strokes gracefully merge into each other, giving depth as well as transparency to the flower.*

2. *Remember, your pattern is a guide and only a guide.*

3. *When picking up more paint on your brush, go back to the same spot on your palette for blending. This is very important, as it enables you to properly fill the brush.*

4. *When I paint roses, I turn the surface so I am comfortably positioned to execute the stroke.*

51

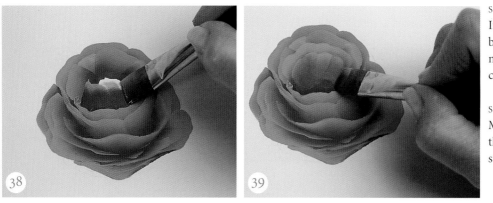

**STEP THIRTY-EIGHT**

If you need to use a smaller brush for the center, by all means do so. Fill the center in carefully with the dark color.

**STEP THIRTY-NINE**

Make a series of scallop strokes that conform to the shape of strokes 4, 5, 6 and 7.

## THE UNDERCOATED ROSE

**STEP FORTY**

If you need to undercoat the rose before beginning the strokes, undercoat using an acrylic craft paint that is similar in color to the rose you are painting. Two or three coats may be necessary to cover. Let dry and cure. Apply a tiny touch of blending gel to the undercoat, then double load your brush and begin stroking.

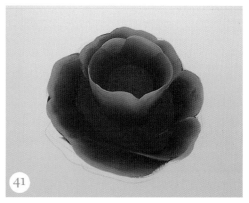

**STEP FORTY-ONE**

This is how your undercoated rose will look with the first thirteen strokes (the shell) completed.

**STEP FORTY-TWO**

The completed undercoated rose.

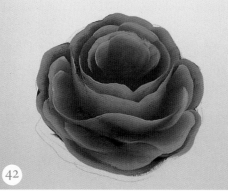

# HINTS

QUESTION: Priscilla, do you ever put dots in the very center of your rose?

ANSWER: *Not often. In my mind there is a magical depth, a feeling of spirit, in the center of the rose that adds warmth. I hate to spoil that feeling. But, if you like dots, use them.*

# Back View of a Rose

Painting a rose from the side or back is always a little different. It is not difficult to paint if you study the flower and paint it step by step. The technique I demonstrate here is more blended than stroked. The stroke technique is also beautiful, but it is not as detailed.

When blending, always paint in at least three values: a dark (or shadow), a medium (or main color) and a light (or highlight).

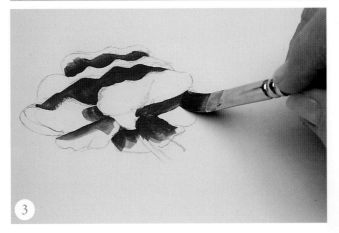

STEP ONE
Transfer this pattern to your practice surface.

STEP TWO
Using a pencil, establish all the dark areas.

STEP THREE
Paint in all shadows using your darkest color.

## HINTS

1. *Be sure to work only one section at a time. Add more gel and more paint as needed.*

2. *The back or side view of a rose may look very strange in the beginning. Keep building those petals and you'll see it take shape.*

3. *When working with acrylics, sometimes I let the paint dry and cure, then paint it a second time if I need additional coverage.*

### STEP FOUR

Turn the flower upside-down and start building petal by petal from the bottom to the top. Apply a touch of blending gel. Reapply the dark color. Add the light color, then use a light touch to blend by following the shape of the petal.

### STEP FIVE

Building and blending a third petal. Notice the shadows, the main color and the highlight.

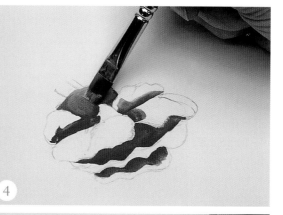

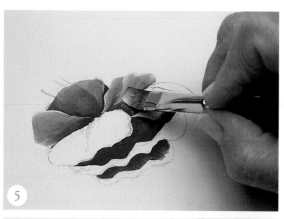

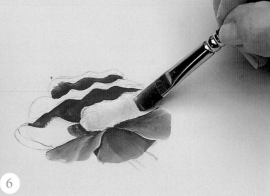

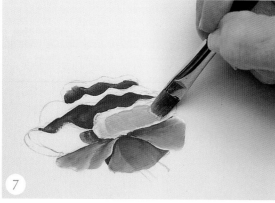

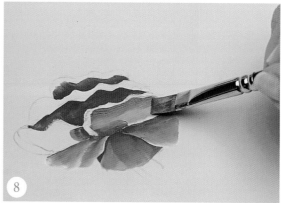

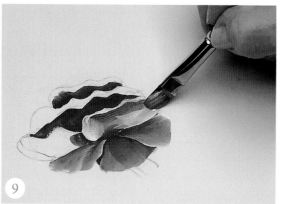

### STEP SIX

A fourth petal. Apply a little blending gel.

### STEP SEVEN

Apply the medium value.

### STEP EIGHT

Apply the light value.

### STEP NINE

Apply the dark value.

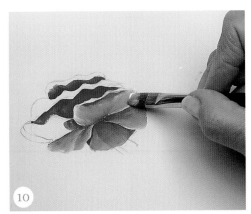

### STEP TEN
Blend following the shape or flow of the petal. (This is the way it grows, from the center out.)

### STEP ELEVEN
Reinforce the dark value and blend.

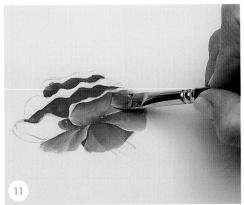

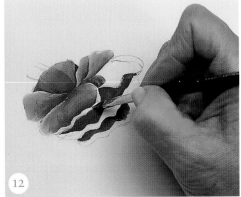

### STEP TWELVE
Use a small flat brush, double-loaded with Titanium White and the medium-value color. Carefully paint the rolled edge.

### STEP THIRTEEN
Continue building the petals one at a time. Don't be afraid to use your own interpretation. When dry, erase any lines you have not covered. Neatly transfer the rose hips and bracts back onto the flower with a white chalk pencil.

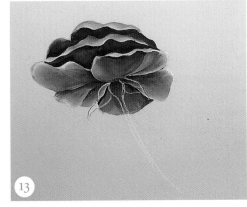

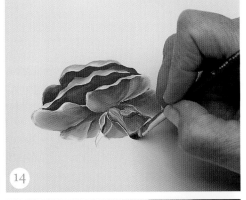

### STEP FOURTEEN
Double load a small flat brush with Hauser Green Light and Green Umber. Paint the bracts, hip and stem. Let dry and apply a second coat, if needed, to cover.

### STEP FIFTEEN
Thorns may be added with a liner brush filled with thinned Green Umber if desired.

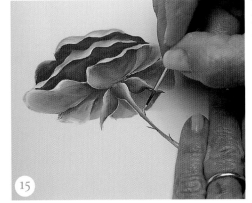

# Details: Filler Flowers

These delicate little flowers can be any color and may come in many different sizes and shapes. Sometimes I don't know where I'm going to place them, but that is why they are called filler flowers. They fill spaces which need that special touch.

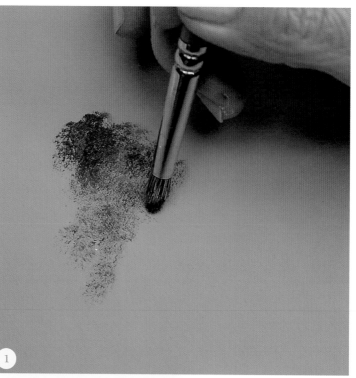

### STEP ONE
Take an old, scruffy brush and dab on a bit of Green Umber (or any color of your choice).

### STEP TWO
While the paint is still wet, pick up a small flat brush and paint tiny five-petal flowers. I tell my students to paint a head, two arms and two legs. You can let the petals overlap and try to create light, medium and dark values.

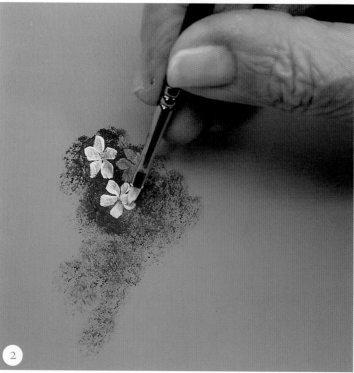

### STEP THREE
Let some flowers be smaller than others.

### STEP FOUR
Add dots of white here and there and add dots of yellow in the center. Let dry.

### STEP FIVE
Make a wash of Green Umber (use a lot of water and just a little color). Apply this on some of the little flowers to the back. The darker color will definitely make some of the flowers recede, making those in the front come forward.

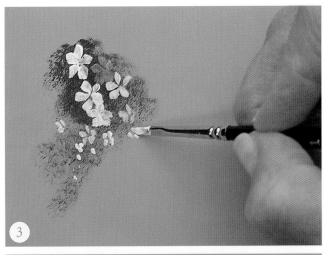

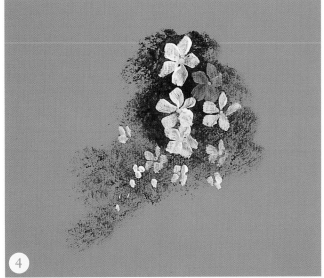

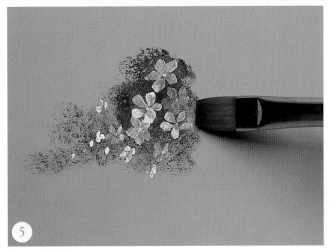

# Details: Ribbons

## BLENDED RIBBON

I will show you two different types of ribbons. There are many, many more. The first is a blended ribbon. The second is string ribbon, painted with thin paint and the liner brush. To achieve proficiency in painting these ribbons, you must practice your skills as with everything else in this book. When you do, the finished product will be outstanding.

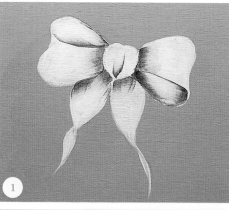

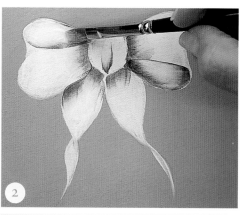

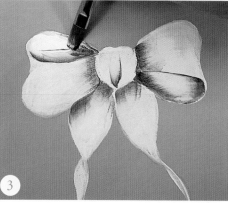

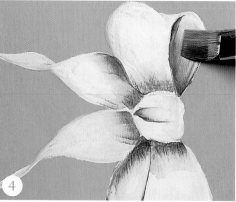

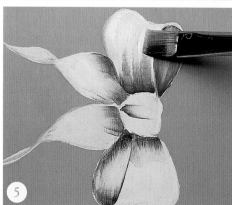

### STEP ONE
Carefully undercoat the ribbon using Wicker White paint. Two or three coats may be needed to cover. Let dry and cure. Float Payne's Gray in all the shadowed areas.

### STEP TWO
Apply blending gel and paint one section of the bow at a time.

### STEP THREE
Apply Titanium White and Payne's Gray as shown.

### STEP FOUR
Wipe the brush and blend, using as large a brush as you are comfortable using.

### STEP FIVE
Continue painting each section of the bow in this manner.

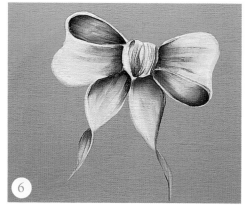

### STEP SIX
The finished, blended bow.

## STRING BOWS & RIBBONS

**STEP ONE**
Fill your no. 1 liner brush with very thin Payne's Gray (or the color of your choice). Start with a dot.

**STEP TWO**
Make a loop flowing from the dot back to the dot.

**STEP THREE**
Continue to make as many loops and streamers as desired.

**STEP FOUR**
Wipe the brush and fill it with thinned white. Highlight by going back over the loops. Don't try to match the lines— just have fun.

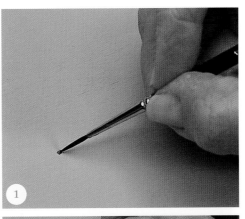

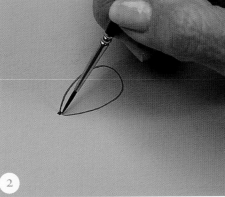

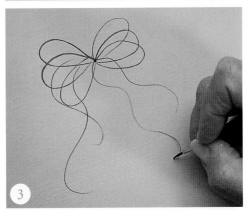

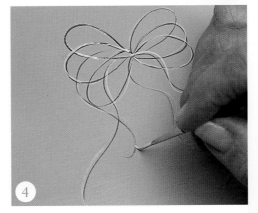

# HINTS

## FOR STRING RIBBON

1. *The paint consistency should be like ink.*
2. *The brush needs to be completely full of paint.*
3. *Hold the brush so the handle points straight up and move it slowly.*
4. *Be sure you can see what you are doing. Increase the magnification or the light if necessary.*

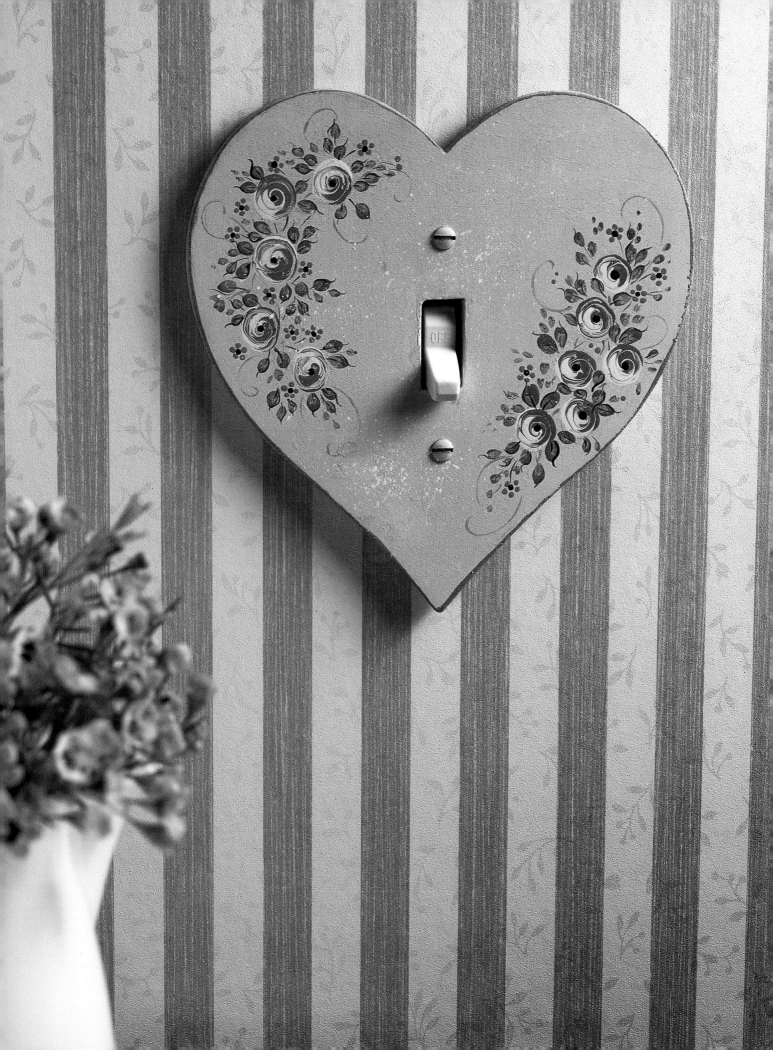

# LIGHT UP WITH ROSES

Light switch plates are used in every room of your home. You can use this heart-shaped switch plate or any other shape that you find in your local hardware store. This is an excellent first project and one that can be easily repeated until you feel comfortable with your results.

These easy roses can be painted with your finger or the eraser of a pencil. Don't be afraid to experiment. You'll love it! What an excellent way to start painting roses!

# Pattern

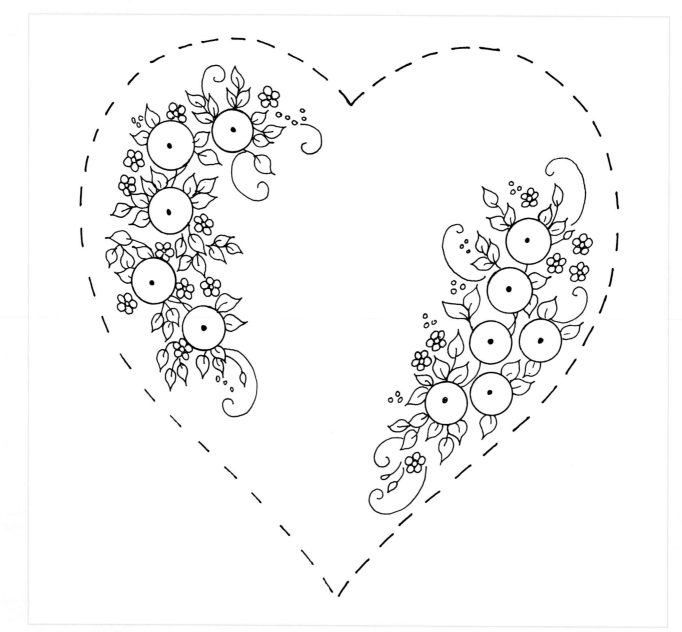

This pattern may be hand-traced or photo-copied for personal use only. It is shown here full size.

# *Colors & Materials*

## MATERIALS

*PAINT: (AP) = FolkArt Artists' Pigments; (A) = FolkArt Acrylics*

BABY PINK
(A)

BURNT UMBER
(AP)

POETRY GREEN
(A)

PRUSSIAN
BLUE (AP)

ROSE PINK
(A)

TRUE
BURGUNDY (AP)

WICKER WHITE
(A)

### SURFACE
- Wooden light switch plate available in local craft stores.

### BRUSHES: LOEW-CORNELL
- Series 7300
  flat no. 1
- Series 7350
  liner no. 1
- Old scruffy brush
- Old toothbrush

### ADDITIONAL SUPPLIES
- Brown paper bag
- Pencil
- Sandpaper
- Soft, absorbent rag
- Stylus
- Tack cloth
- Tracing paper
- Water-based varnish

## PREPARATION

1. Sand if needed. Wipe with a tack cloth.
2. Paint the switch plate with a mixture of Baby Pink + Wicker White (1:1). Two or more coats will be needed to cover. Let dry before applying a second coat. When dry, rub with a piece of brown paper bag with no printing on it to smooth the nap of the wood.
3. Neatly trace and transfer the pattern.

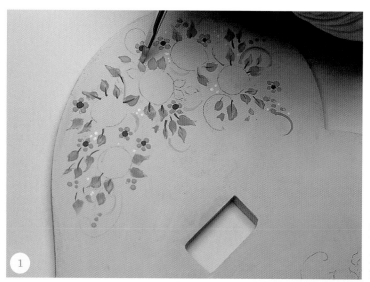

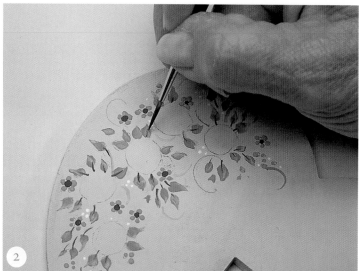

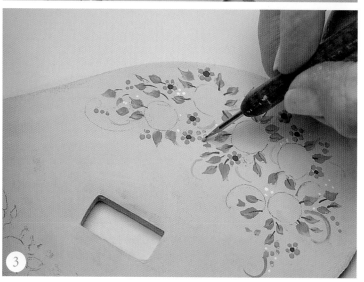

### STEP ONE

Undercoat the leaves with Poetry Green. Two coats will be needed to cover.

### STEP TWO

The veins are painted with the liner brush and thinned Burnt Umber.

### STEP THREE

The dots and dot flowers are painted with the large end of the stylus using a mix of Wicker White + Prussian Blue (6:1). The centers are dots of Burnt Umber. Be sure your paint has been thinned with water.

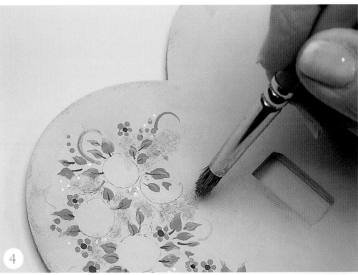

### STEP FOUR
Using an old scruffy brush, dab a very small amount of Poetry Green around the roses and leaves

### STEP FIVE
Using your little finger or the eraser of a pencil, paint a dot of Rose Pink for the base of the rose.

### STEP SIX
While the paint is still wet, use your stylus and add a dot of True Burgundy to the center.

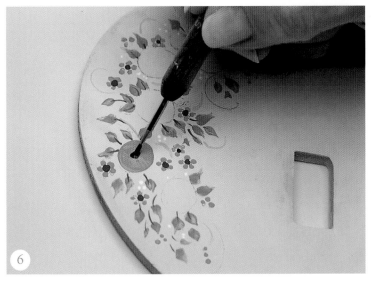

# Finishing Touches

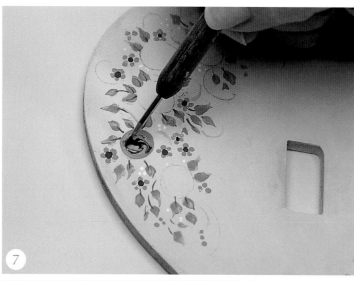

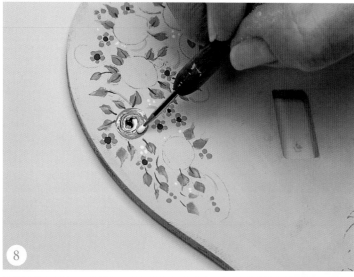

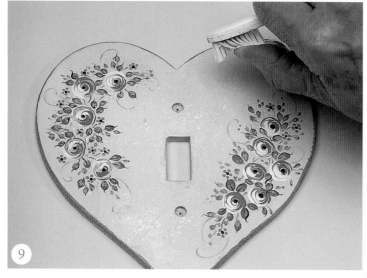

### STEP SEVEN
Swirl the True Burgundy into the wet paint with a stylus.

### STEP EIGHT
Wipe the stylus and pick up Wicker White. Swirl the Wicker White into the wet paint. Don't be afraid of it. Practice and play with it. Each one will be different.

### STEP NINE
Add line work and accents if desired. Trim the outside edge in Baby Pink. Let dry and then varnish with two or three coats of the water-based varnish of your choice. To flyspeck, dip an old tooth-brush in water, blot on the soft absorbent rag, rub the tooth-brush in a circle in thinned paint, and then blot on the rag. Pull your thumb over the bristles and watch the specks fly.

## HINT

1. *Dip your thumb in water before flyspecking. This will help you clean the paint from under your fingernails.*
2. *Before flyspecking your finished piece, practice on an old brown paper grocery bag.*

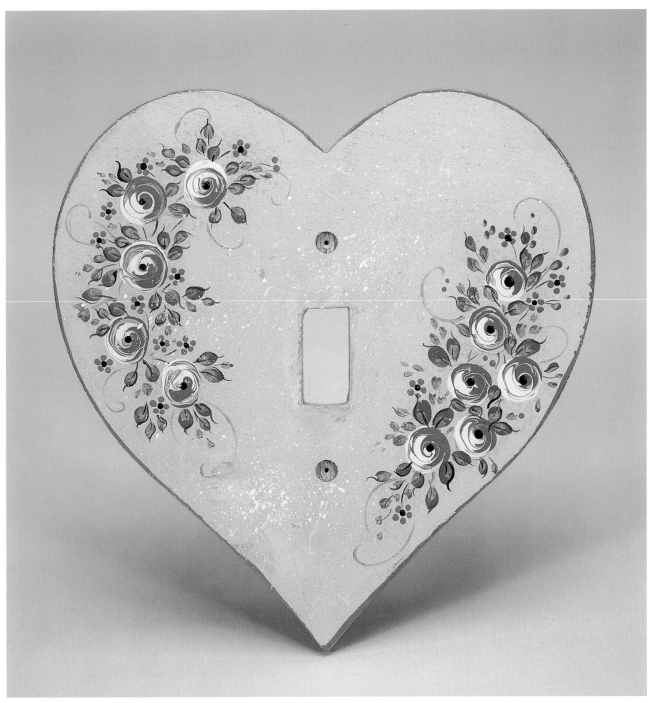

Finished switch plate.

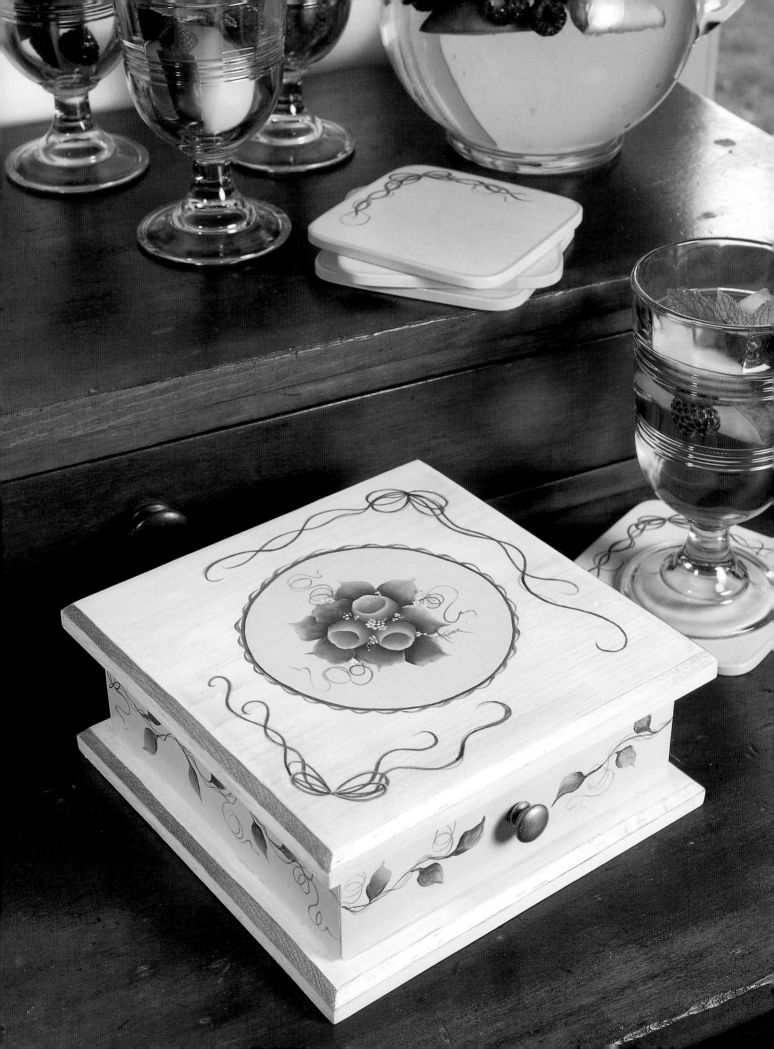

# WINE & ROSES

It's amazing how many different accessories can be painted with rosebuds. I really enjoy painting usable items for the home, and this wooden box full of coasters would certainly be enjoyed by anyone. This is a great surface to paint and give as a hostess gift. Here's to you and the roses.

# Patterns

These patterns may be hand-traced or photo-copied for personal use only. Enlarge at 200% to bring them up to full size.

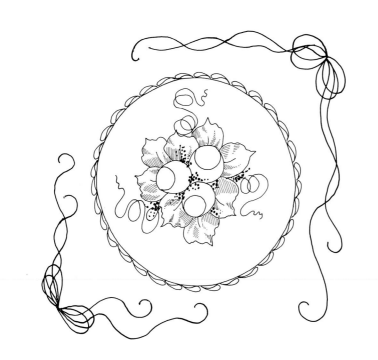

# Colors & Materials

## MATERIALS

*PAINT: (AP) = FolkArt Artists' Pigments; (A) = FolkArt Acrylics*

GREEN UMBER (AP)   ICE BLUE (AP)   ICE GREEN LIGHT (AP)   POETRY GREEN (A)   PURE GOLD METALLIC (M)

ROSE PINK (A)   TITANIUM WHITE (AP)   TRUE BURGUNDY (AP)   WICKER WHITE (A)   YELLOW LIGHT (AP)

### SURFACE
- Wooden box with coasters available from:
  Valhalla Designs
  343 Twin Pines Drive
  Glendale, OR 97442

### BRUSHES: LOEW-CORNELL
- Series 7300
  flat no. 6
- Series 7350
  liner no. 1
- Old scruffy brush

### ADDITIONAL SUPPLIES
- Brown paper bag
- Compass
- FolkArt Blending Gel Medium
- FolkArt Glazing Medium
- Sandpaper
- Stylus
- Tack cloth
- Tracing paper
- Water-based varnish

## PREPARATION

1. Sand if needed. Wipe with a tack cloth.
2. Stain with a mixture of glazing medium and Wicker White (5:1). Let dry. Rub with a piece of brown paper bag with no printing on it to smooth the nap of the wood.
3. Neatly trace and transfer an accurate circle. Use a compass if needed.
4. Paint the circle with two or more coats of Ice Green Light. Paint the edges of the box with Ice Green Light. Let dry.
5. Neatly trace and transfer the pattern.

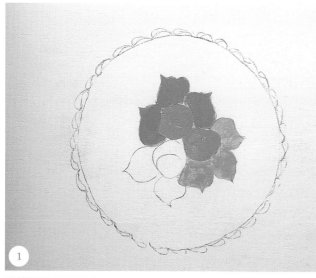

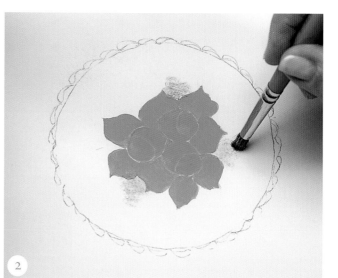

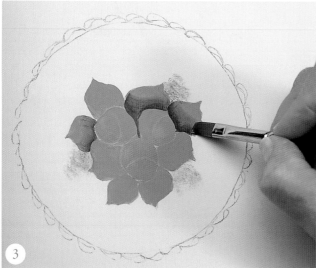

### STEP ONE
Using a no. 6 flat brush, neatly and carefully undercoat the leaves with Poetry Green. Two coats will be needed to cover. Undercoat the roses with two or more coats of Rose Pink. Let dry and cure.

### STEP TWO
Using a scruffy brush, dab on a thin coat of Green Umber in three different places, as illustrated.

### STEP THREE
Paint the underneath or back leaves first. Anchor a shadow of Green Umber using your no. 6 flat brush. Let dry.

### STEP FOUR
Apply a little blending gel and apply Green Umber on top of the anchored shadow. Apply Poetry Green above the Green Umber, and Ice Blue at the tip of the leaf.

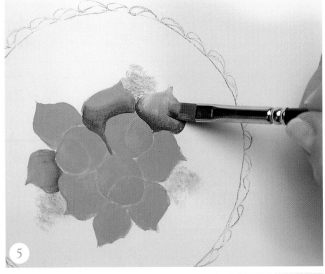

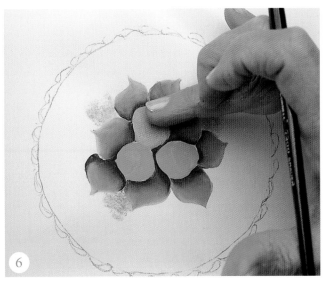

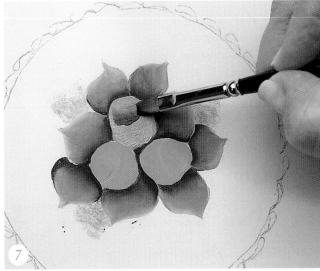

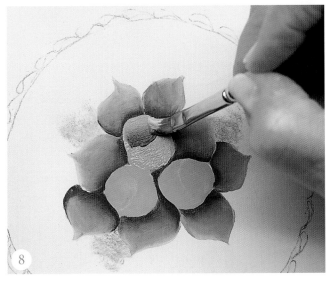

### STEP FIVE

Wipe the brush and blend the colors together. Use a light touch when blending. Complete all the leaves in this manner.

### STEP SIX

Complete one rosebud at a time. Apply a tiny bit of blending gel with your finger.

### STEP SEVEN

Pick up True Burgundy and apply a stroke of color in the center.

### STEP EIGHT

Double load the brush with True Burgundy and a mix of True Burgundy + Titanium White (1:3). Paint an upside-down U-stroke around the stroke of True Burgundy, catching the color with the corner of your brush and blending it into the petal.

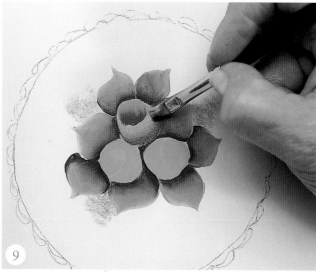

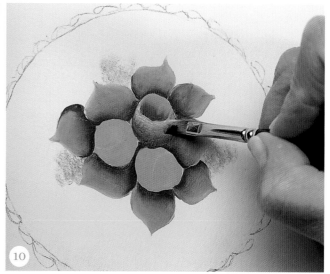

### STEP NINE

For the rose bowl, double load the brush with True Burgundy and the lighter pink mix you just made. Paint a right-side-up U-stroke and let the ends of this U touch the ends of the upside-down U.

### STEP TEN

Pick up more light pink mix and carefully fill in under the center.

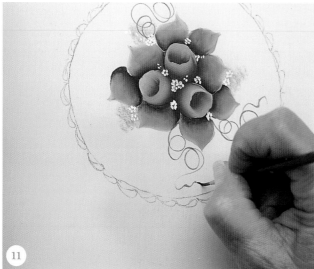

### STEP ELEVEN

Add dot flowers of thinned Wicker White using the point of your liner brush or stylus. The centers are Yellow Light. Curlicues are painted with the liner brush and thinned Green Umber.

### STEP TWELVE

The border is painted with the liner brush and thinned Green Umber. Don't worry if your hand shakes; mine does and no one ever notices.

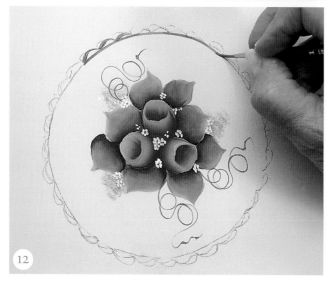

# The Finished Coaster Set

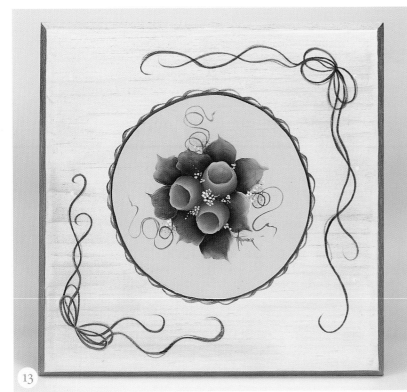

13

### STEP THIRTEEN

To finish the coaster set, add line work, bows and streamers; then add border leaves around the edges, as shown on page 37. Trim with Pure Gold Metallic paint. Let dry. Varnish with two or more coats of the water-based varnish of your choice.

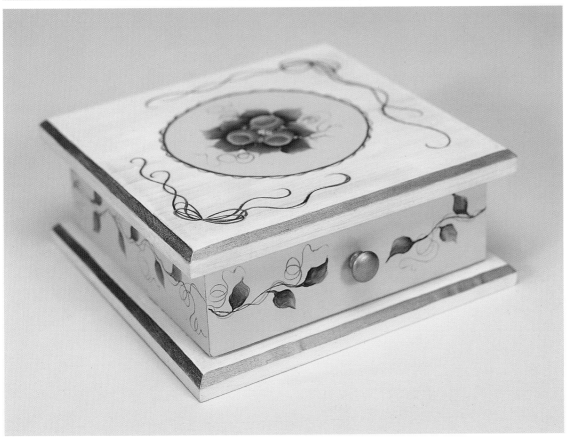

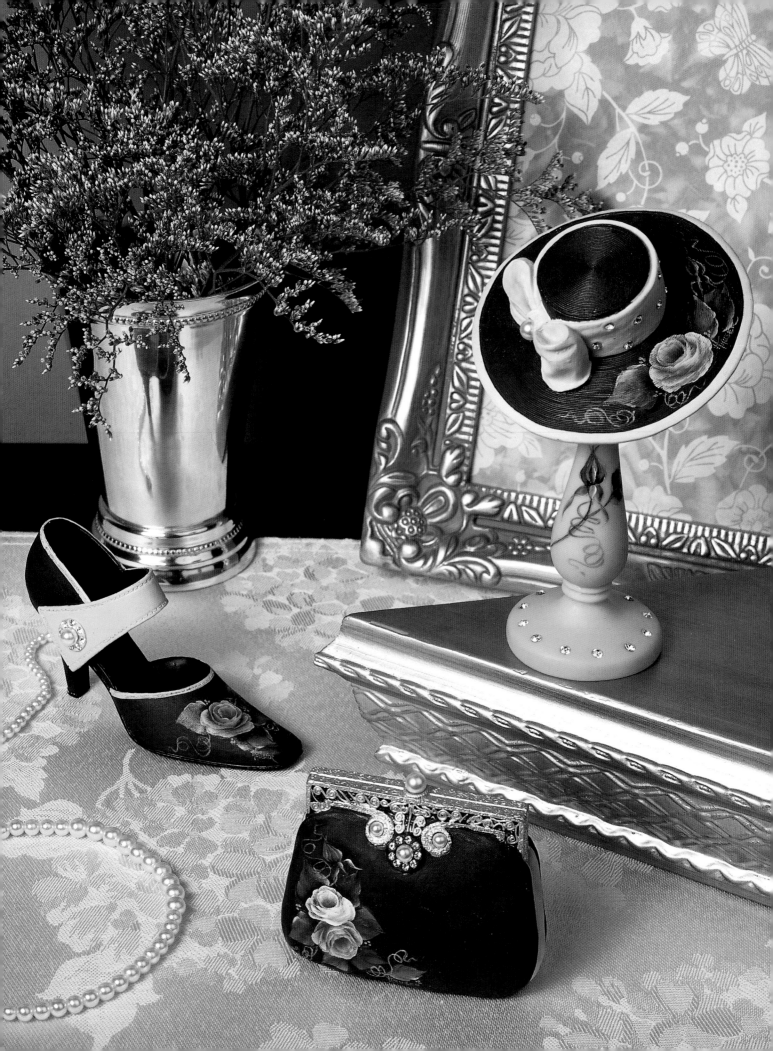

# MIDNIGHT & ROSES

 What fun these little miniatures are to paint—but you must be able to see them! I am not going to tell you how old I am, but at forty I began to use an Optivisor, which is a wonderful magnifying glass that fits around my head and pulls down over my glasses. You can also paint your real shoes, your real evening bag and even the brim of a wonderful hat in the same way you paint the miniatures.

# *Pattern*

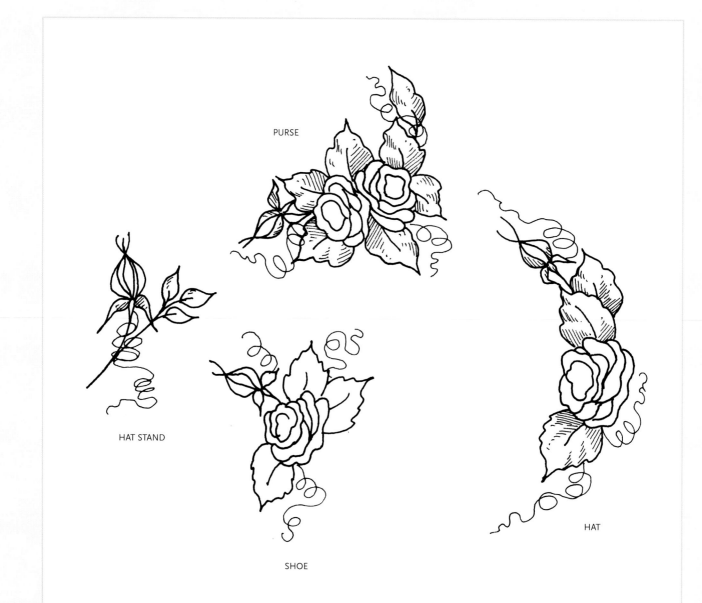

PURSE

HAT STAND

SHOE

HAT

This pattern may be hand-traced or photocopied for personal use only. Reduce at 75% to return it to full size.

# Colors & Materials

## M A T E R I A L S

### PAINT: FolkArt Artists' Pigments

BURNT UMBER    HAUSER GREEN DARK    HAUSER GREEN LIGHT    HAUSER GREEN MEDIUM

ICE BLUE    TITANIUM WHITE    TRUE BURGUNDY

### SURFACE
- Miniature purse, hat, shoe and hat stand (found in gift shops)

### BRUSHES: LOEW-CORNELL
- Series 7300
  flat no. 1
- Series 7350
  liner no. 1

### ADDITIONAL SUPPLIES
- Optivisor (optional)
- Stylus
- Water-based varnish
- White graphite paper

## P R E P A R A T I O N

1. Neatly trace and transfer the pattern to the rough surface.
2. Use white graphite paper with a stylus and go over the lines several times to be sure you can see the transferred design.

# Tiny Leaves & Roses

**STEP ONE**

The transferred design.

**STEP TWO**

Double load your no. 1 flat brush with Hauser Green Medium and Burnt Umber. When double loading tiny brushes, use very tiny puddles of paint. Remember, your puddles should always be in proportion to your brush size.

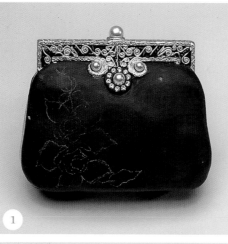
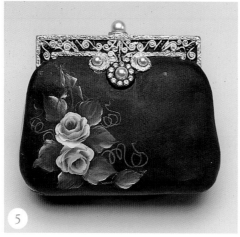

**STEP THREE**

Paint the dark leaves using Hauser Green Dark, Burnt Umber, Hauser Green Medium and Ice Blue. For the medium leaves, use Hauser Green Medium, Burnt Umber, Hauser Green Light and Titanium White. For the light leaves, use Hauser Green Light, Burnt Umber and Titanium White. A touch of True Burgundy may be added in the shadow area of all the leaves to reflect the color of the little roses.

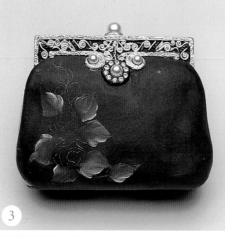
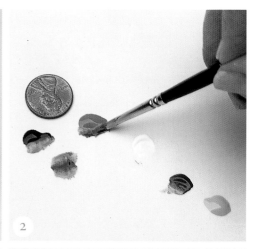
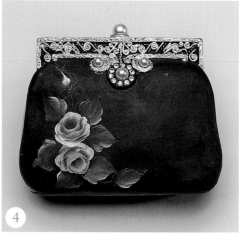

**STEP FOUR**

Step-by-step instructions for the roses can be found on pages 43-52. Even though the brush you are using here is much smaller, the technique is the same. Here I used the no. 1 flat, double loaded with True Burgundy and Titanium White.

**STEP FIVE**

To paint the green curlicues, fill the no. 1 liner brush with thinned Titanium White + a touch of Burnt Umber.

# Completed Miniatures

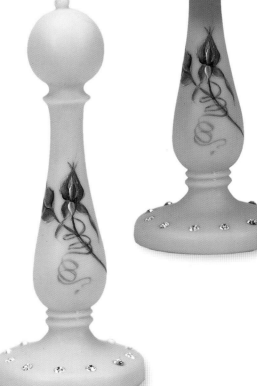

**Completed Hat With Stand, Purse & Shoe**
If desired, varnish either the design only or the whole surface with two or more coats of the water-based varnish of your choice.

## HINTS

1. *Always turn your piece as you work so you are in the most comfortable position possible for painting.*
2. *You'll notice in the photo that I did not need to undercoat this type of surface. It is a rough surface, and the paint adheres nicely. However, undercoating may be applied if preferred.*

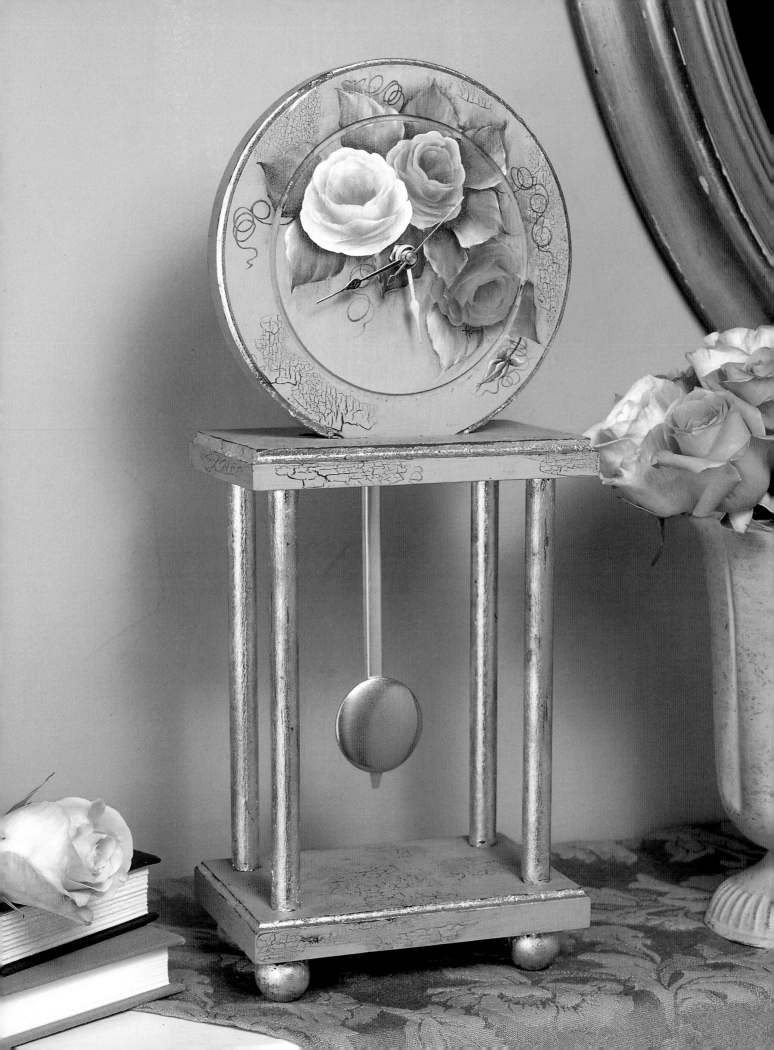

# MAGICAL TIME FOR ROSES

 This wonderful clock teaches us to use crackling techniques in specific areas. It also teaches us how to apply gold leaf. It is so easy to turn unfinished or old pieces into heirlooms. Just take the time to learn how, and the magic will be yours.

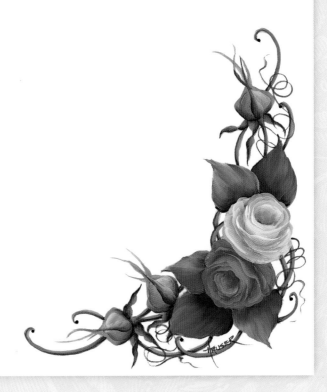

# *Pattern*

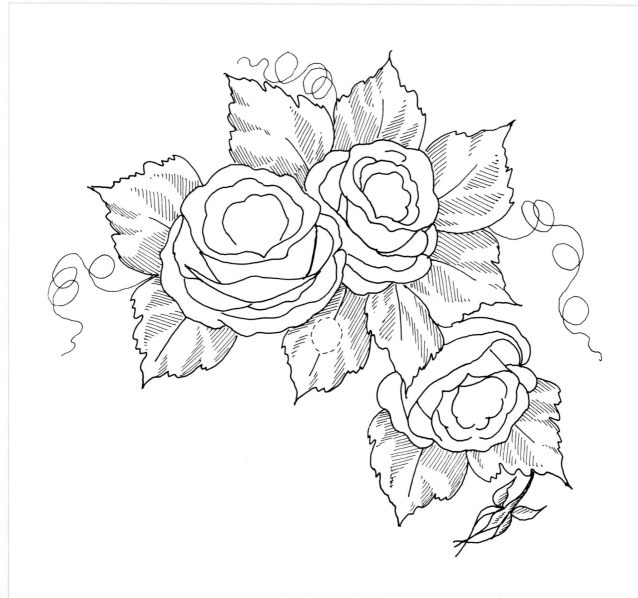

This pattern may be hand-traced or photocopied for personal use only. This pattern is full size.

# Colors & Materials

## MATERIALS

*PAINT: (AP) = FolkArt Artists' Pigments; (A) = FolkArt Acrylics*

AUTUMN LEAVES (A)    BLACK CHERRY (A)    BURNT SIENNA (AP)    BURNT UMBER (AP)    HAUSER GREEN DARK (AP)    HAUSER GREEN LIGHT (AP)    HAUSER GREEN MEDIUM (AP)    ICE BLUE (A)

ITALIAN SAGE (A)    OLD IVY (A)    PAYNE'S GRAY (AP)    PRUSSIAN BLUE (AP)    RED LIGHT (AP)    TITANIUM WHITE (AP)    TRUE BURGUNDY (AP)

### CORAL ROSE MIXES

MEDIUM CORAL MIX
(Titanium White + Dark Coral mix 3:1)

DARK CORAL MIX
(Burnt Sienna + Red Light + True Burgundy 2:2:1)

LIGHT CORAL MIX
(Titanium White + Dark Coral mix 6:1)

## SURFACE
- Walnut Hollow open base clock, small no. 23022
- Walnut Hollow Pendulum movement, small no. TQ810P

## BRUSHES: LOEW-CORNELL
- Series 7300 flats nos. 2, 10
- Series 7350 liner no. 1
- Series 7550 1-inch (25mm) wash brush
- Series 9040 ¹⁄₂-inch (12mm) mop
- Old scruffy brush

## ADDITIONAL SUPPLIES
- Brown paper bag
- Clear acrylic spray
- Composition gold leaf
- FolkArt Blending Gel Medium
- FolkArt Crackle Medium
- FolkArt Glazing Medium
- Gold leaf sizing
- Plastic wrap
- Sandpaper
- Scissors
- Soft piece of velveteen
- Stylus
- Tack cloth
- Water-based satin varnish
- Waxed paper
- White graphite paper

## PREPARATION

1. Sand and wipe the unfinished clock with a tack cloth.
2. See steps two through four on the following page for detailed step-by-step instructions for preparing this surface.

# *Basecoating the Clock*

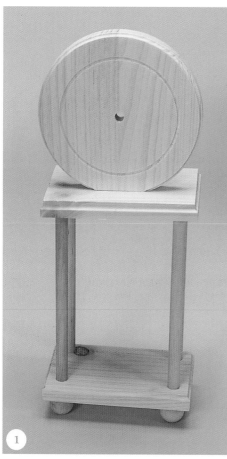

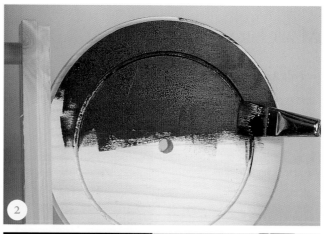

**STEP ONE**
Sand and wipe the unfinished clock with a tack cloth.

**STEP TWO**
Paint the entire clock Black Cherry. Let dry. Apply a second coat, if needed. Let dry thoroughly. Rub with a piece of brown paper bag to smooth the surface.

**STEP THREE**
Apply the crackle medium in several different spots. Crackle medium takes between one and two hours to dry.

**STEP FOUR**
Apply a generous amount of Italian Sage over the clock's face and cross pieces. Don't go back over your brushstrokes or your paint will lift. Very lightly seal the crackled area with clear acrylic spray. Anytime you spray, work in a well-ventilated area. Let the spray dry thoroughly. Transfer the pattern.

## HINT

*If your paint does lift, quickly wipe it off with a damp rag and start over.*

**STEP FIVE**
Apply the undercoat to the design. Undercoat the leaves with Old Ivy with the no. 10 flat brush. The rose is undercoated in Autumn Leaves.

**STEP SIX**
Using as large a brush as possible, double load the brush with glazing medium on one side and Payne's Gray on the other. Blend on the palette to soften the color so it blends beautifully through the hairs of the brush from dark to medium to light. Use only a small amount of paint.

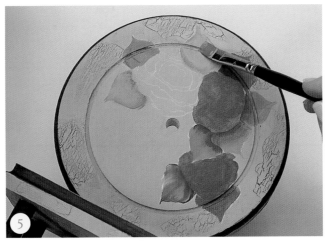

## HINT

*If you don't have these exact colors, any paint that is approximately the same color will work beautifully—don't sweat the small stuff.*

## BACKGROUND COLOR

*Background color is a soft float of color behind or around the design. It's easier to put it on before the decorative painting is applied, but it can also be put on afterwards.*

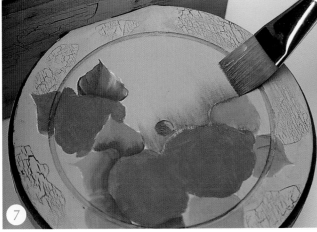

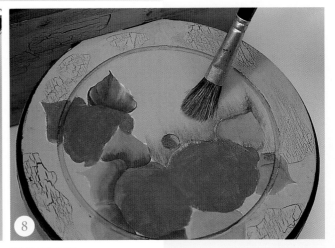

**STEP SEVEN**
Apply the background color around the outside edge of the undercoated design.

**STEP EIGHT**
If needed, soften the outside edge of the background color with a mop brush, your finger or a sponge before the paint dries.

# Leaves

STEP NINE

When painting any design, start from the back and work forward. Since these leaves have been undercoated, it will help if you anchor the shadows on the leaves before you paint them. To do this, double load a no. 10 flat brush with water and a mix of Burnt Umber plus a touch of Prussian Blue. Anchor your shadows.

For the photograph, I have chosen an indented area to paint on. Some people think it is hard to paint on such an area. Just do your best and continue painting.

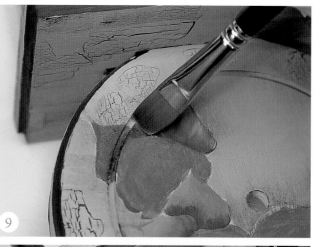

STEP TEN

Paint the first two leaves following the instructions on pages 31-34. Then, paint the rose. Make a Dark Coral mix (Burnt Sienna + Red Light to True Burgundy 2:2:1). This will be the darkest value in your rose.

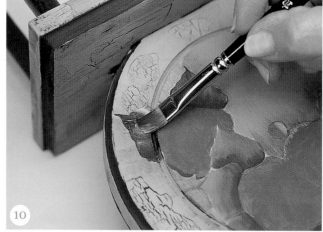

STEP ELEVEN

Apply a little blending gel.

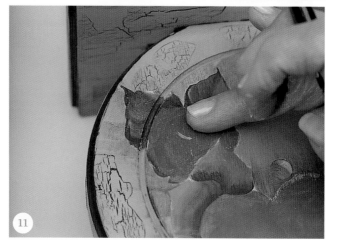

STEP TWELVE

Double load the brush with the Dark Coral mix and the Medium Coral mix (Titanium White + Dark Coral Mix 3:1). Begin building your rose as taught on pages 43-52. (Please notice that I am painting over the leaf.)

STEP THIRTEEN

Now, use your finger or a brush to remove the portion of the rose that is under the leaf.

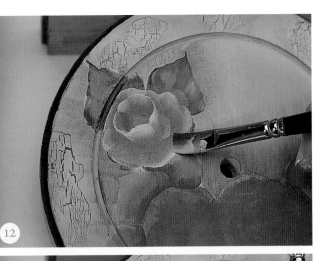

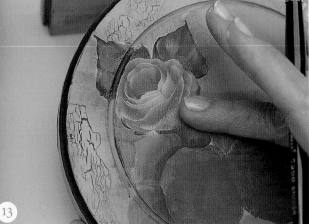

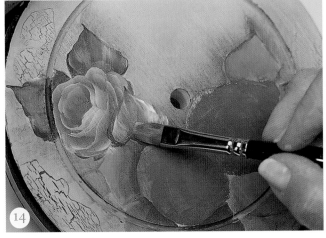

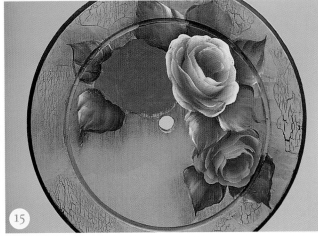

STEP FOURTEEN

Paint the leaf over the rose. Notice how beautiful the leaf is because I caught a touch of the wet rose color and blended it into the leaf.

STEP FIFTEEN

To create this medium-value rose, I used the Light Coral mix (Titanium White + Dark Coral mix 6:1) and the Dark Coral mix.

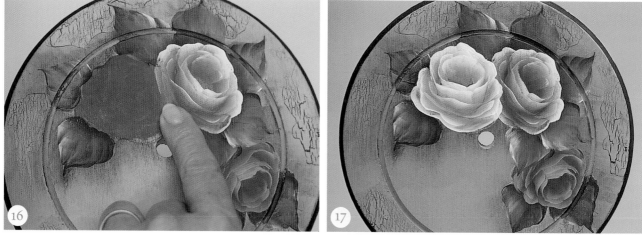

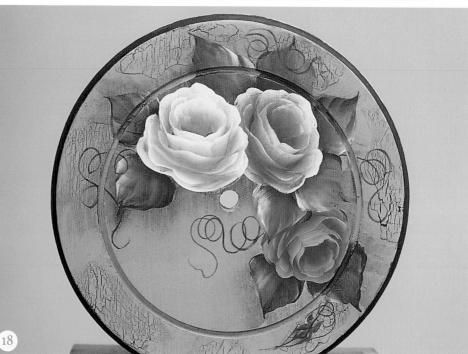

### STEP SIXTEEN

With your finger or a brush, lift out the area of the rose that will be under the top of the lightest-value rose.

### STEP SEVENTEEN

For the lightest-value rose, double load your brush with the Medium Coral mix and the Light Coral mix. Build your rose.

### STEP EIGHTEEN

Paint your rosebuds and curlicues following the step-by-step instructions on pages 39-42.

Applying gold leaf is easy to do. Traditionally, an oxide-red color is used under the leafing. On the clock, I use gold leaf as a trim.

### STEP NINETEEN

Using an old brush, apply the gold leaf sizing over the Black Cherry color. As the sizing dries, it will change from a milky-white color to clear. When it is completely clear (after about 45 minutes), apply the composition leaf.

### STEP TWENTY

Place the gold leaf between two sheets of waxed paper or plastic wrap. Rub your hands together to create heat. Press your warm hand onto the waxed paper. The heat from your hand will cause the leafing to adhere to the paper.

### STEP TWENTY-ONE

Cut the leaf into small strips. This will make it much more manageable.

### STEP TWENTY-TWO

Carry the leaf to the area that you sized. Remove the waxed paper or plastic wrap and apply the leaf directly to the sizing. The leaf will adhere only to the sizing.

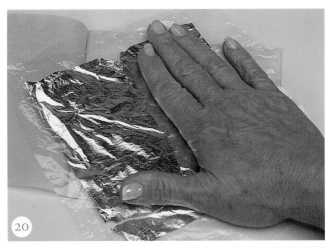

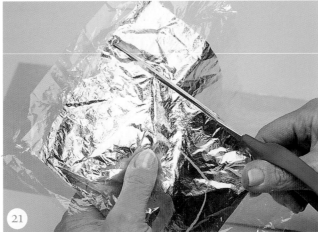

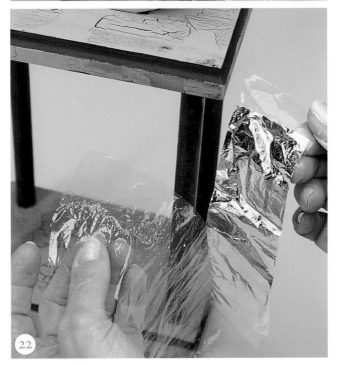

# GOLD LEAF, *continued*

### STEP TWENTY-THREE
Pat the gold leaf firmly into place with your fingers.

### STEP TWENTY-FOUR
When the gold leaf has properly adhered to the column, remove the top sheet of waxed paper or plastic wrap.

### STEP TWENTY-FIVE
Let the gold leaf dry for 24 hours, then burnish or rub with a piece of velveteen. Don't worry if little holes or cracks appear. You can patch them or leave them as they are. It is really beautiful to have some of the background color showing through.

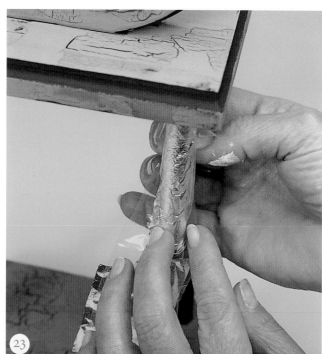

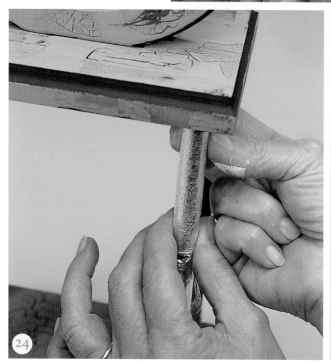

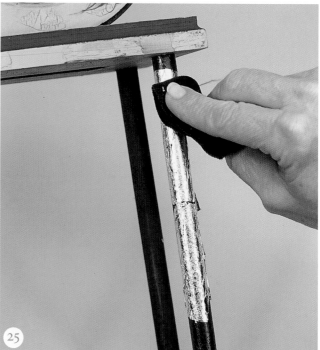

# Completed Clock

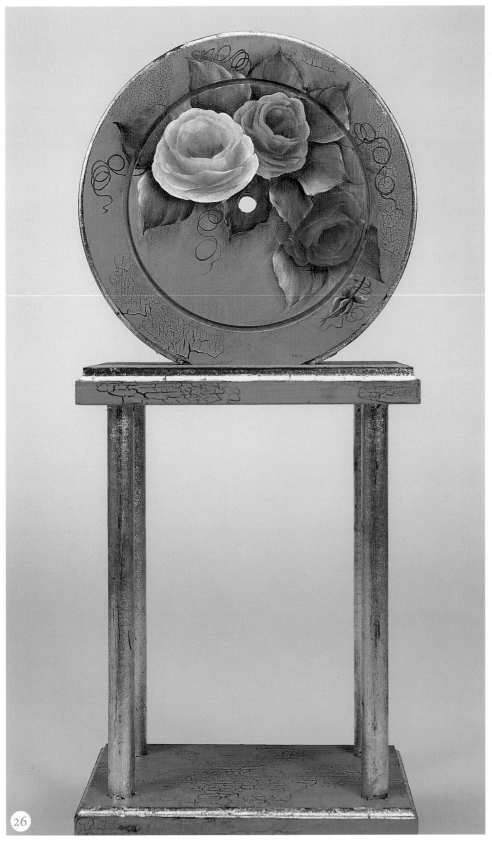

**STEP TWENTY-SIX**

Let dry and cure. Varnish with two or three coats of water-based satin varnish, or the varnish of your choice.

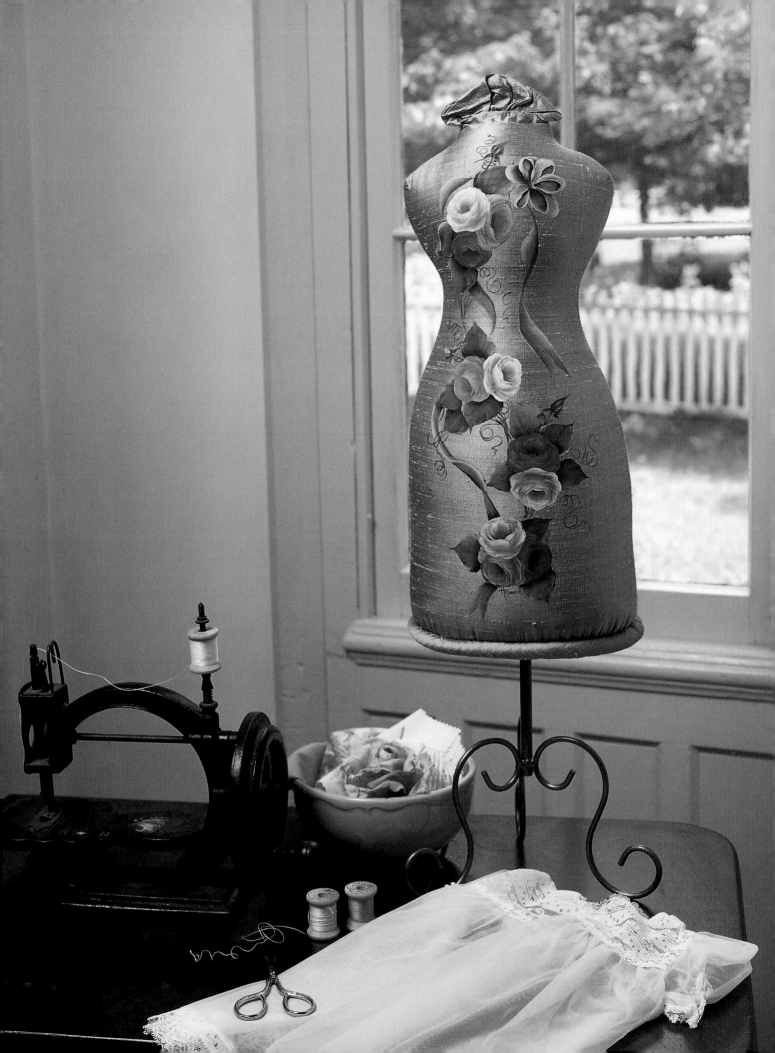

# SILKEN ROSES

 Painting on fabric is one of my favorite things to do, especially on unusual pieces like this adorable dress form. Simply transfer your design, then carefully apply the textile medium directly to the fabric. Work in one small section at a time. When I transferred the design, I used white chalk on the back of my pattern. However, if it is hard for you to see the chalk, white graphite paper may be used.

# Pattern

This pattern may be hand-traced or photocopied for personal use only. Enlarge at 182% to bring it up to full size.

# Colors & Materials

## MATERIALS

### PAINT: FolkArt Artists' Pigments

BURNT SIENNA

BURNT UMBER

GREEN UMBER

HAUSER GREEN DARK

HAUSER GREEN LIGHT

HAUSER GREEN MEDIUM

PAYNE'S GRAY

PRUSSIAN BLUE

RED LIGHT

TITANIUM WHITE

TRUE BURGUNDY

### SURFACE
- Dupioni silk dress form (found in gift shops)

### BRUSHES: LOEW-CORNELL
- Series 7300
  flats nos. 2, 4, 8, 10
- Series 7350
  liner no. 1

### ADDITIONAL SUPPLIES
- FolkArt Textile Medium
- Stylus
- White chalk or white graphite paper

## PREPARATION

There is really no preparation involved in painting this surface. This is a great project for those who enjoy a quick start. Just remember to apply the textile medium to the surface before painting the design.

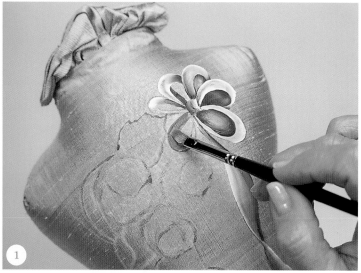

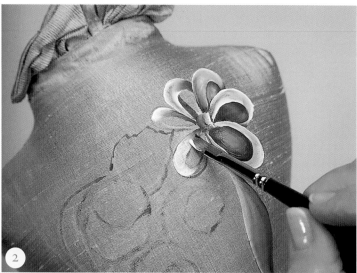

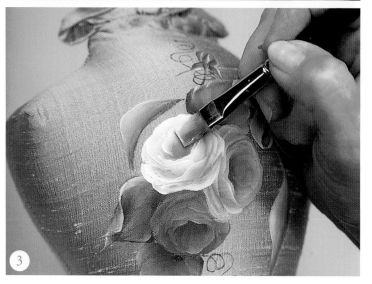

### STEP ONE
Apply the textile medium to one small section.

### STEP TWO
Double load a no. 4 flat brush with Titanium White and Green Umber. Paint bows following the step-by-step instructions found on page 58. Wipe the brush and blend.

### STEP THREE
Paint the leaves and then the roses, buds and curlicues following the step-by-step directions in Chapter 3.

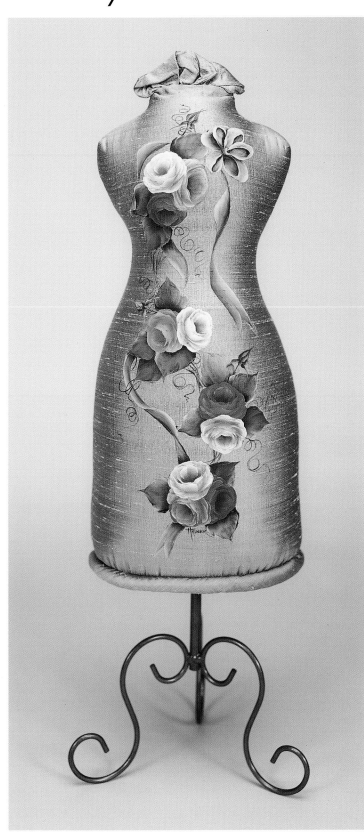

## HINT

1. If you make a mistake and drop your brush onto the fabric, there is not an easy way to correct it. Never fear. Simply add another stream of ribbon, a leaf or a rosebud. The only person who will know is you.

2. If you are painting on fabric that can be washed before painting, go ahead and wash it. It is important to remove any sizing that might be in new fabric before transferring the design and painting on it.

3. With acrylics, I don't find it necessary to heat set when finished. Believe me, when you get acrylic paint on your smock and it dries, you know by experience that the color doesn't wash out.

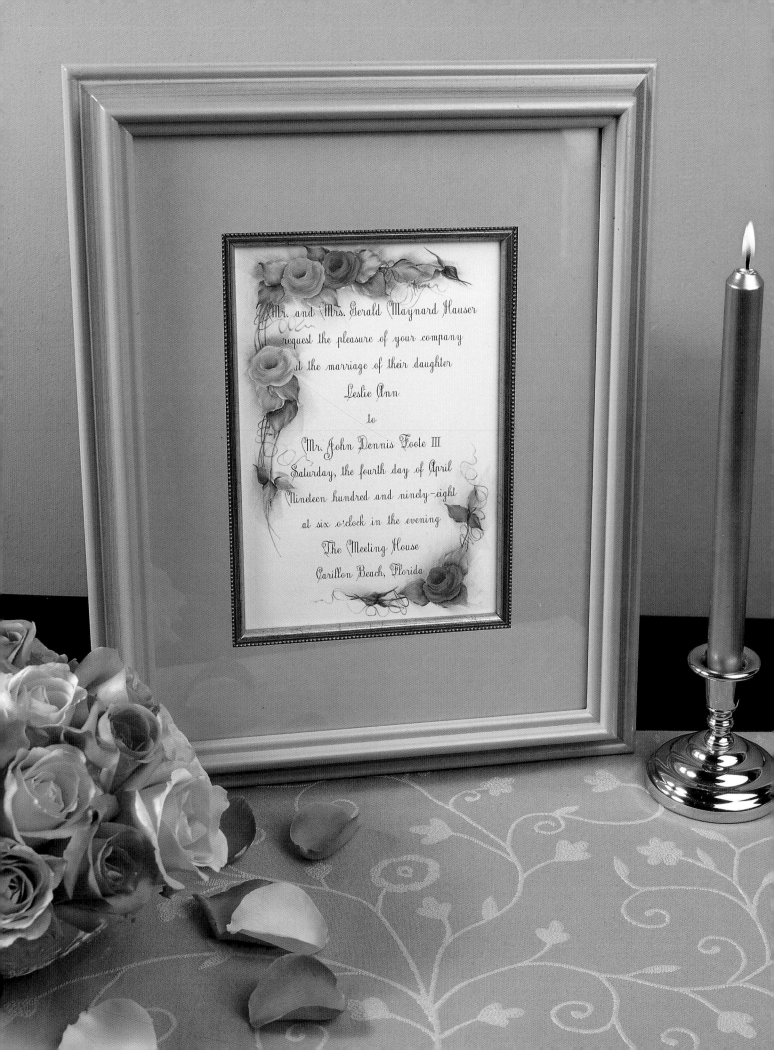

Mr. and Mrs. Gerald Maynard Hauser

request the pleasure of your company

at the marriage of their daughter

Leslie Ann

to

Mr. John Dennis Foote III

Saturday, the fourth day of April

Nineteen hundred and ninety-eight

at six o'clock in the evening

The Meeting House

Carillon Beach, Florida

# A BEAUTIFUL GIFT

 Oh, how I loved our children's weddings—after they were over! Actually, the preparation was really an absolutely wonderful part of each event. Our daughters waited years for me to paint their wedding invitations. But the end result, I think you'll agree, is well worth the wait!

This pattern may be hand-traced or photocopied
for personal use only. Pattern is shown full size.

# *Colors & Materials*

 ## MATERIALS

### PAINT: *FolkArt Artists' Pigments*

| BURNT SIENNA | GREEN UMBER | HAUSER GREEN LIGHT | RED LIGHT | TITANIUM WHITE | TRUE BURGUNDY |
|---|---|---|---|---|---|

### CORAL ROSE MIXES

DARK CORAL MIX
(Burnt Sienna + Red Light + True Burgundy 2:2:1)

MEDIUM CORAL MIX
(Titanium White + the Dark Coral mix 3:1)

LIGHT CORAL MIX
(Titanium White + Dark Coral mix 6:1)

### SURFACE
- A wedding invitation

### BRUSHES: LOEW-CORNELL
- Series 7300
  flat no 16
- Series 7350
  liner no. 1

### ADDITIONAL SUPPLIES
- Clear acrylic spray
- FolkArt Blending Gel Medium
- Kneaded eraser
- Pencil
- Stylus
- White chalk or white graphite

## PREPARATION

1. Neatly trace and transfer the design. I used a graphite pencil on the back of the pattern.

# Background

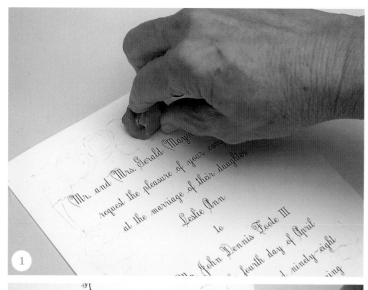

### STEP ONE

After transferring the design to the invitation, use a kneaded eraser to soften the lines so you can hardly see them.

### STEP TWO

Apply the background color using a no. 16 or larger flat brush. Double load it with water and a tiny touch of Green Umber. We are actually making the acrylics work like watercolor. Flow or apply this color around the leaves.

### STEP THREE

Rinse the brush and apply the Dark Coral mix next to the roses. Double load the brush with water plus a tiny touch of the Dark Coral mix. Hopefully you'll use enough water to let the colors bleed into each other. Let dry. Seal the paper by misting with several light coats of clear acrylic spray in a well-ventilated area.

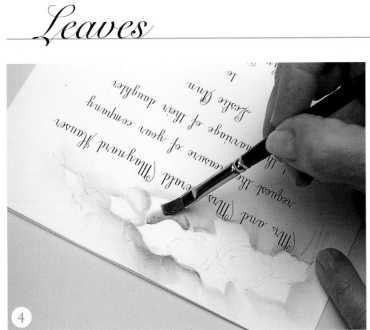

### STEP FOUR

Using a brush double-loaded with water and Green Umber, float on an anchor for the leaf. Remember, only a tiny amount of paint is used.

### STEP FIVE

Apply a tiny bit of blending gel to the leaf.

### STEP SIX

Stroke on the dark side with a little Green Umber and stroke on the light side with a little Titanium White.

**7**

**8**

### STEP SEVEN

Add a tiny bit of Titanium White and a tiny bit of Hauser Green Light in the center. Wipe the brush and blend using a light touch. A touch of the Dark Coral mix can be added in the shadow of the leaf to reflect the color of the rose.

### STEP EIGHT

Now paint the roses. The rose on the bottom is painted with the Dark Coral mix and the Medium Coral mix. The top rose is painted with the Medium Coral mix and the Light Coral mix. A touch of the Dark Coral mix is added for additional depth in the center of the rose. Curlicues are painted with a no. 1 liner brush and thinned Green Umber. Paint the leaves and then the roses, buds and curlicues.

## HINT

1. *Use just a little bit of color in order to create the look of watercolor.*
2. *If you are working on very thin paper, it will buckle if you get it too wet.*
3. *Practice this water and acrylic background technique on other paper surfaces. If you have trouble, seal the paper by misting it with several light coats of clear acrylic spray in a well-ventilated area.*

# Completed Invitation

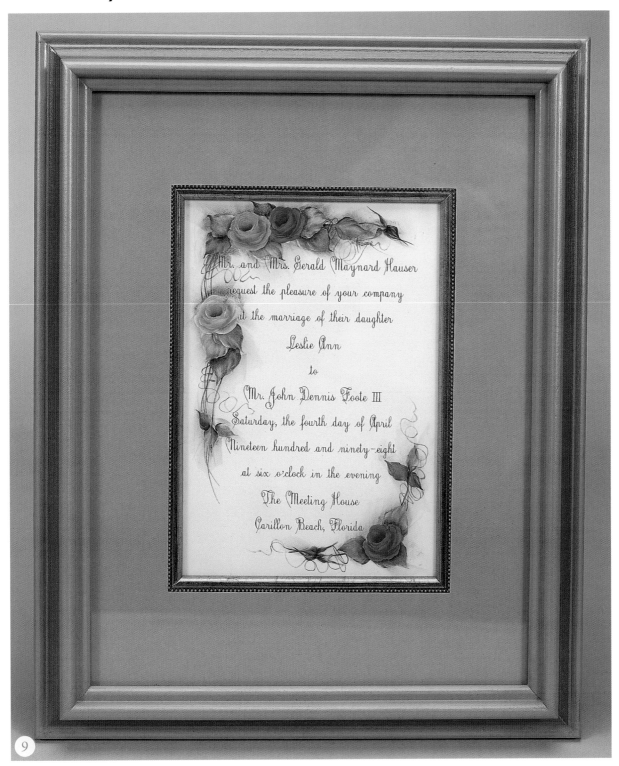

**STEP NINE**
I generally do not do anything to the painting except put it in a beautiful frame that truly complements the invitation and the occasion.

# AUNT KATHY'S HATBOX

I love to paint hatboxes. They are adorable placed on an armoire. A stack of them creates a charming table. They are just plain fun, and so feminine! A hatbox, painted with a group of yellow, pink and coral roses and tied with a pretty ribbon, makes a terrific gift or decorative accessory.

# Pattern

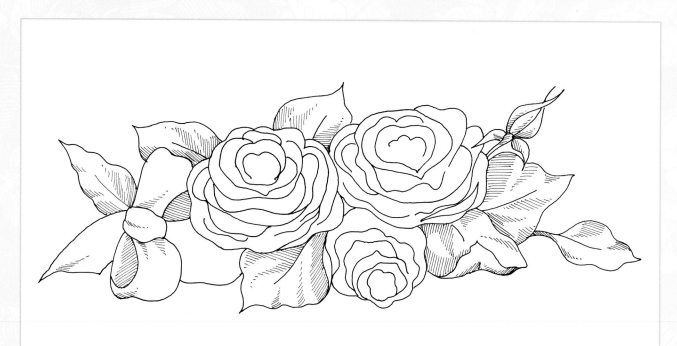

This pattern may be hand-traced or photocopied for personal use only. Enlarge at 133% to bring it up to full size.

# MATERIALS

*PAINT: (AP) = FolkArt Artists' Pigments; (A) = FolkArt Acrylics*

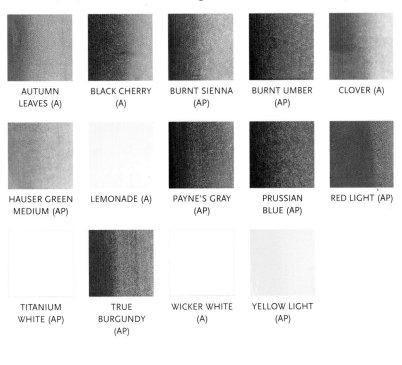

| | | | | |
|---|---|---|---|---|
| AUTUMN LEAVES (A) | BLACK CHERRY (A) | BURNT SIENNA (AP) | BURNT UMBER (AP) | CLOVER (A) |
| HAUSER GREEN MEDIUM (AP) | LEMONADE (A) | PAYNE'S GRAY (AP) | PRUSSIAN BLUE (AP) | RED LIGHT (AP) |
| TITANIUM WHITE (AP) | TRUE BURGUNDY (AP) | WICKER WHITE (A) | YELLOW LIGHT (AP) | |

## SURFACE
- Hatbox with paper finish (widely available in gift and craft stores)

## BRUSHES: LOEW-CORNELL
- Series 7300 flats nos. 0, 8, 10, 12

## ADDITIONAL SUPPLIES
- FolkArt Blending Gel Medium
- FolkArt Textile Medium
- Stylus
- Water-based varnish
- White graphite paper

# PREPARATION

1. Be sure your surface is clean.
2. Neatly trace and transfer your design.

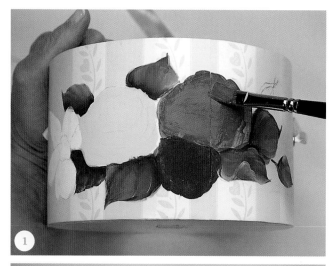

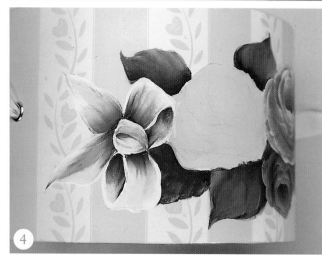

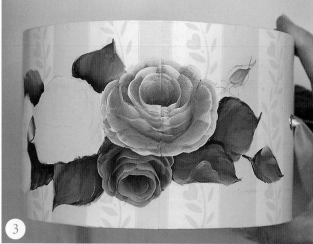

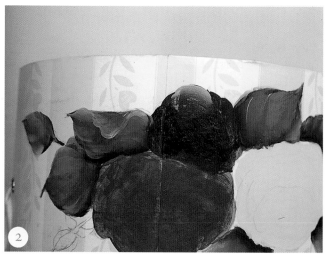

### STEP ONE

Undercoat the leaves with Clover, the pink rose with Black Cherry, the coral rose with Autumn Leaves, the yellow rose with Lemonade. If these colors are not available, choose something similar. Undercoat the ribbon in Wicker White. Paint the leaves as instructed on pages 31-34.

### STEP TWO

Apply a little blending gel. To paint the pink rose make a mixture of True Burgundy + Red Light (1:1). This will be your dark mix. For your light mixture, use the dark mix + Titanium White (1:3). Look where I began my stroke. Do you see how the paint lifted? This is what happens if you put blending gel down before your undercoat has dried and cured.

### STEP THREE

Paint the coral rose. The dark mixture is True Burgundy + Burnt Sienna + Red Light (1:2:2). For the lighter color, mix a tiny touch of the dark mixture into Titanium White (1:4).

### STEP FOUR

Paint the bow. Work one section at a time. Apply blending gel, Titanium White and Payne's Gray. Detailed instructions can be found on page 58.

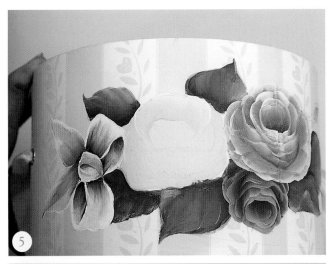

### STEP FIVE

Begin the yellow rose. The dark mix is Yellow Light + Burnt Sienna (2:1). The light mix is the dark mix + Titanium White (1:5). Apply a little blending gel over the undercoated rose. Double load a no. 10 brush with the dark and light mix. Blend on the palette to soften the color. Paint the first three petals.

### STEP SIX

Pick up a tiny touch of Burnt Sienna on the dark side of the brush. Continue painting with this combination through stroke 7.

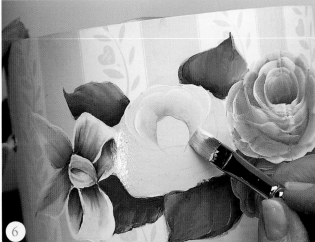

### STEP SEVEN

Pick up a tiny bit more Burnt Sienna on the dark yellow side of the brush. Paint strokes 8-13. You are actually mixing the yellow mix + the Burnt Sienna on the brush as you paint. It is fine to go back over strokes as long as you go over the entire stroke. You will notice some transparency on stroke 13 where the petal goes over the leaf. When that petal dries, I will go back over this stroke two or three times.

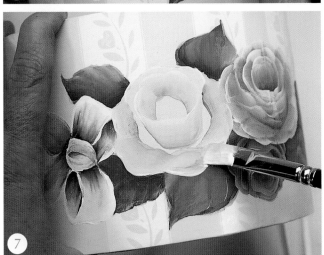

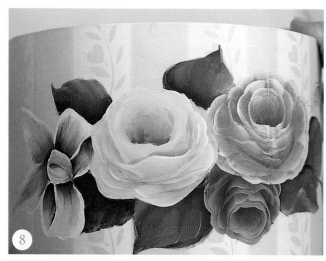

### STEP EIGHT

You are now ready to paint stroke 14 of your rose. Pick up a little more Titanium White on the light side of your brush. Continue building the whole rose with the same colors in the brush. Remember, you are in control. Add a little more white or yellow as needed.

### STEP NINE

Paint the filler flowers with the no. 0 flat brush loaded with thinned Titanium White. I paint a head, two arms and two legs to create the five little petals. Add additional dots here and there. If desired, a tiny dot of Yellow Light can be added to the center. Let dry and cure.

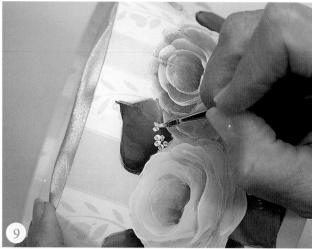

### STEP TEN

Make a wash using water and a tiny touch of Prussian Blue. Using your no. 8 flat brush, apply this wash over your little flowers here and there. Let dry. Add the curlicues and stems. Let dry.

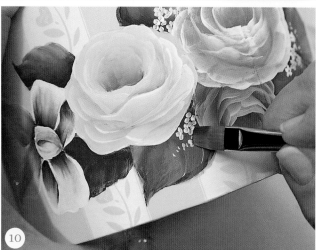

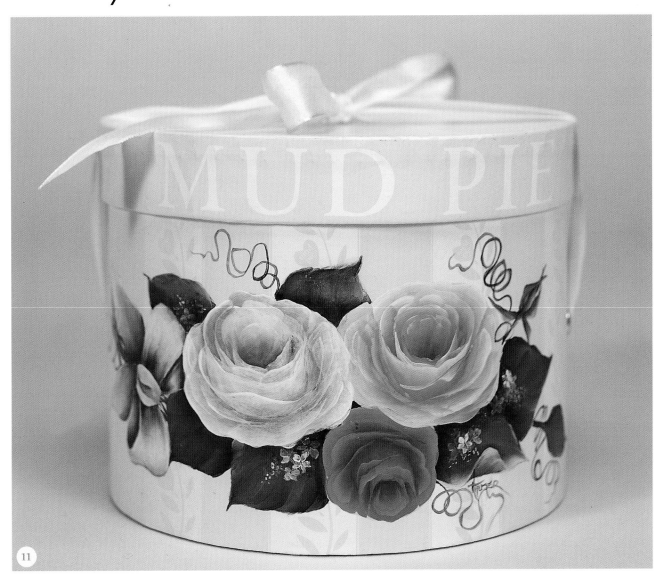

**STEP ELEVEN**
Apply two or more coats of the water-based varnish of your choice.

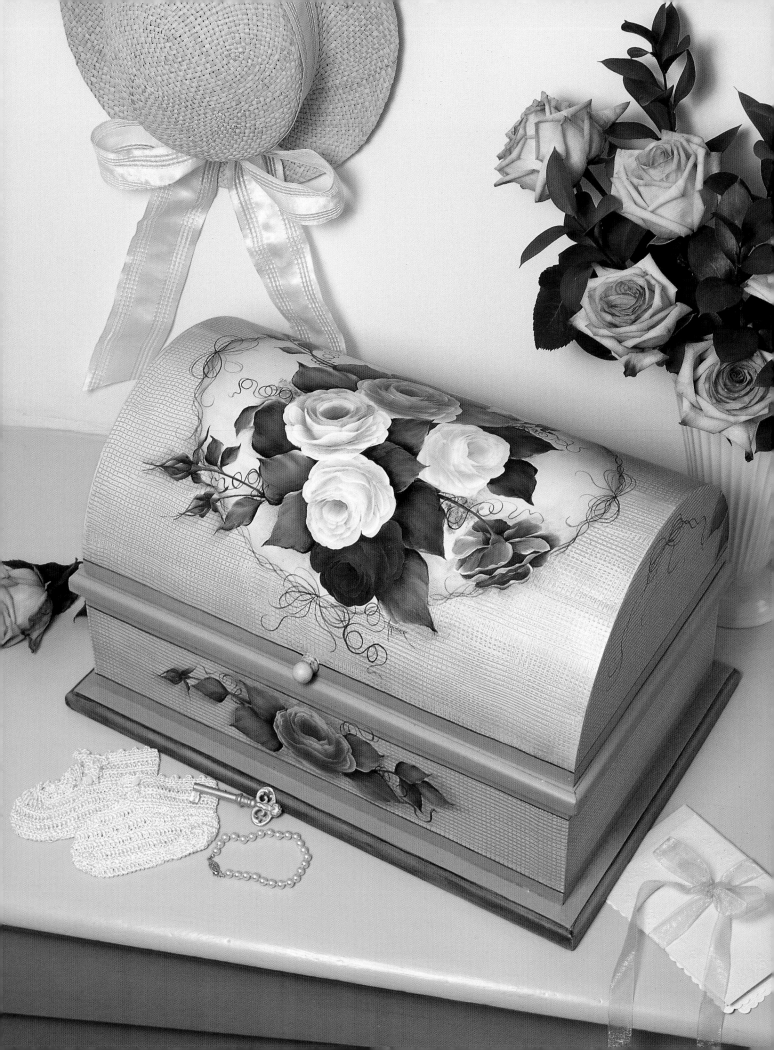

# LESLIE'S WEDDING TRUNK

I've always loved to paint—and teach painting—on trunks of all sizes. Many years ago, it was a trunk covered with roses that inspired me, at age twelve, to want to paint them. I asked my parents to buy a wonderful rose-covered trunk for me that I had noticed at a local antique store. Instead, at Christmas I received a camel-backed trunk—*not* covered with roses. Inside the trunk was a note telling me to learn to paint the roses myself. You know the rest of the story...

A bouquet of multicolored roses adorns this beautiful little trunk. It is a cherished keepsake that can be handed down through the generations. We use it for all those extra wedding photos and favorite mementos of the special day.

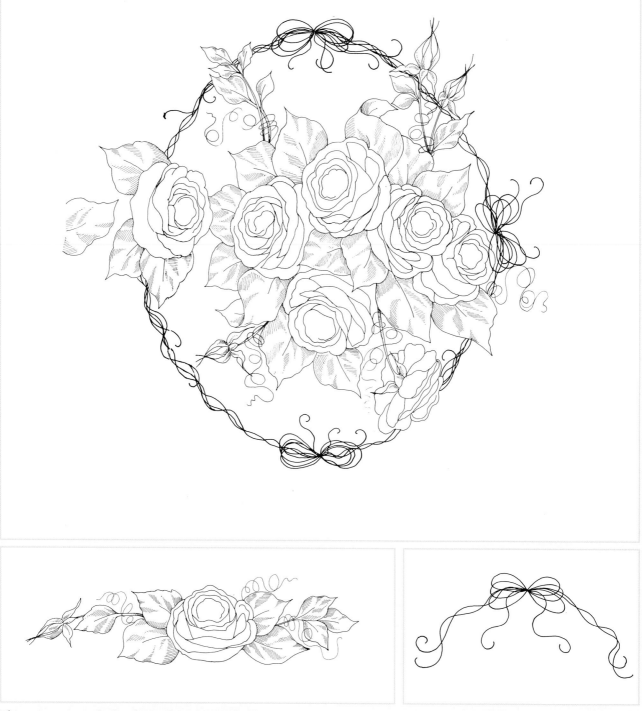

These patterns may be hand-traced or photocopied for personal use only. Enlarge at 285% to bring them up to full size.

# *Colors & Materials*

## MATERIALS

*PAINT: (AP) = FolkArt Artists' Pigments; (A) = FolkArt Acrylics*

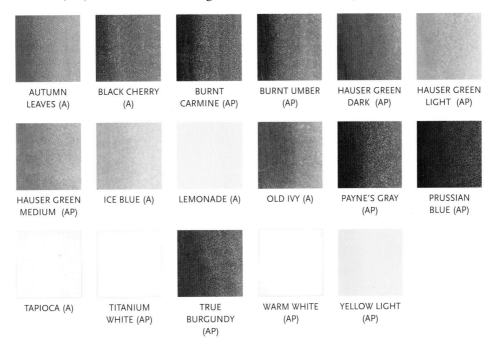

| AUTUMN LEAVES (A) | BLACK CHERRY (A) | BURNT CARMINE (AP) | BURNT UMBER (AP) | HAUSER GREEN DARK (AP) | HAUSER GREEN LIGHT (AP) |
| --- | --- | --- | --- | --- | --- |
| HAUSER GREEN MEDIUM (AP) | ICE BLUE (A) | LEMONADE (A) | OLD IVY (A) | PAYNE'S GRAY (AP) | PRUSSIAN BLUE (AP) |
| TAPIOCA (A) | TITANIUM WHITE (AP) | TRUE BURGUNDY (AP) | WARM WHITE (AP) | YELLOW LIGHT (AP) | |

### SURFACE
- Unfinished wooden trunk available from:
  Valhalla Designs
  343 Twin Pines Drive
  Glendale, OR 97442

### BRUSHES: LOEW-CORNELL
- Series 7300
  flats nos. 14
- Series 7350
  liner no. 1
- 1-inch (25mm) wash brush
- 2-inch (50mm) foam brush
- Old scruffy brush
- Rubber faux finish comb

### ADDITIONAL SUPPLIES
- Brown paper bag
- Contact paper
- FolkArt Glazing Medium
- Rubber cement pick-up tool
- Sandpaper
- Scissors
- Soft cotton rag or paper towel
- Stylus
- Tack cloth
- Water-based varnish
- White graphite paper or white chalk

## PREPARATION

1. Sand if needed. Wipe with a tack cloth.
2. Basecoat the lid of the trunk with two or more coats of Tapioca. Let dry. Rub with a piece of brown paper bag with no printing on it to smooth the nap of the wood.

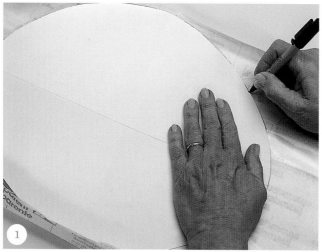

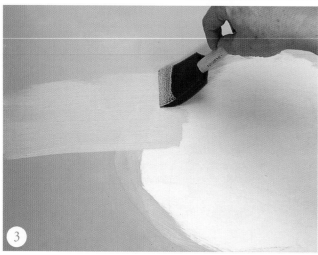

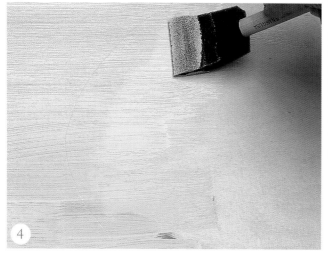

### STEP ONE
Transfer the oval pattern in the design onto a piece of contact paper. Carefully cut out the oval.

### STEP TWO
Center the contact paper onto the dried and cured trunk lid. Slowly remove the backing paper.

### STEP THREE
Using a 2-inch (50mm) foam brush, basecoat the entire trunk in Ice Blue. Let dry.

### STEP FOUR
Mix Tapioca and glazing medium (1:1) on the utility palette. Brush this mixture over the Ice Blue surface and on top of the contact paper. If you cannot work fast, do this in four sections.

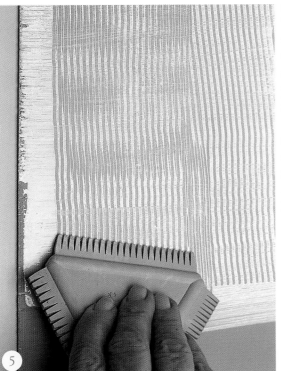

### STEP FIVE

Using a rubber comb, comb vertically through the glaze. Occasionally wipe the comb onto a soft, absorbent cloth or paper towel to remove the excess glaze.

### STEP SIX

Quickly (while the glazing medium is still wet) comb across horizontally (overlapping won't hurt anything). Let dry.

### STEP SEVEN

Carefully pull off the contact paper, revealing the Tapioca oval.

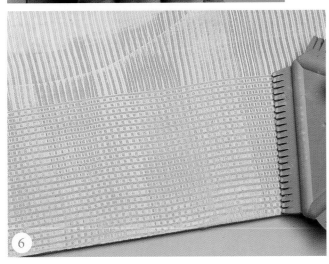

# Painting the Design

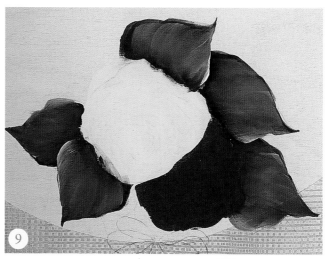

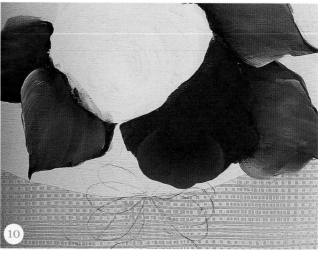

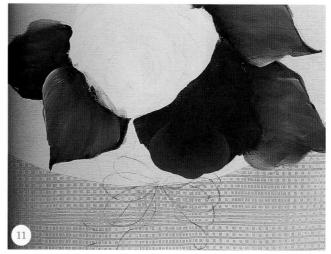

### STEP EIGHT

Neatly trace and transfer your design to the Tapioca oval and beyond. Undercoat the leaves with Old Ivy, the lemon rose in Lemonade, the coral rose in Autumn Leaves, and the pink roses in Black Cherry.

### STEP NINE

Now you are ready to paint the leaves. Notice which leaves are in the very back of the design and paint them first. Colors for the dark leaves are Hauser Green Dark (shaded with Burnt Umber and a touch of Prussian Blue) + Ice Blue and Hauser Green Medium; the medium leaves are Hauser Green Medium (shaded with Burnt Umber + a touch of Prussian Blue) + Hauser Green Light, Titanium White and Yellow Light; the light leaves are Hauser Green Light (shaded with a mixture of Burnt Umber + a touch of Prussian Blue), Titanium White and Hauser Green Dark. Don't forget to use a touch of the flower color in the shadow area of the leaves. For detailed instruction on leaf painting, see pages 31-34.

### STEP TEN

For the very deep burgundy rose, mix Burnt Carmine and True Burgundy (1:1). For the lighter color, mix Warm White with the deep burgundy mix (1:1). Double load a no. 14 flat brush with these two colors. Paint strokes 1, 2 and 3.

### STEP ELEVEN

Paint the remaining strokes. Refer to pages 43-51 for detailed instructions on painting the rest of the rose strokes.

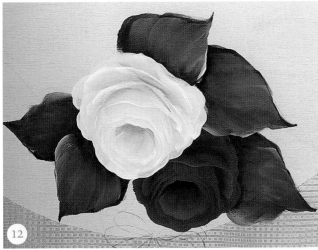

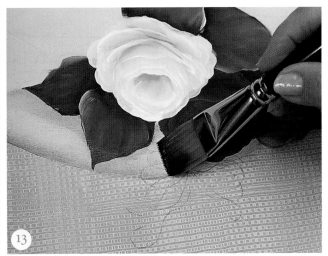

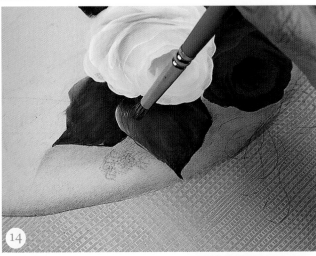

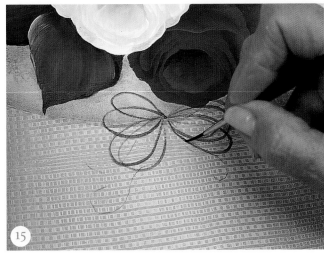

### STEP TWELVE
The yellow rose is next. Refer to pages 113–114 for detailed instructions.

### STEP THIRTEEN
After you have finished painting the design, add a little bit of background color. To do this, double load your 1-inch (25mm) wash brush with glazing medium on one side of the brush and a little Payne's Gray on the other side. Blend on the palette to soften the color. Carefully apply this background color around the edges of your painting to create this soft, gentle shadow. Float this same mixture around the inside edge of your oval.

### STEP FOURTEEN
Using an old scruffy brush, dab on a little Payne's Gray here and there to fill in the areas between the groupings of leaves.

### STEP FIFTEEN
Fill the no. 1 liner brush full of thinned Payne's Gray. Make a dot to begin to form a bow. Make as many loops as desired from any dot as shown in the photograph.

**STEP SIXTEEN**
Highlight the bow with thinned Warm White.

**STEP SEVENTEEN**
Many streamers of thinned Payne's Gray and Warm White flow from the bows around the edge of the oval.

**STEP EIGHTEEN**
To finish the bottom edge of the trunk, antique with a mix of glazing medium + Payne's Gray (2:1). Using a soft cotton rag, wipe off as much as desired.

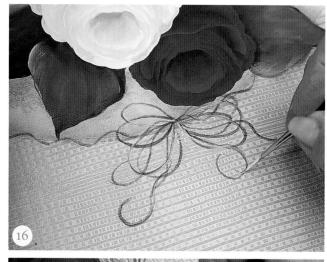

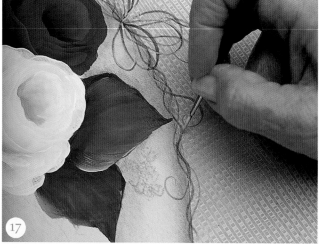

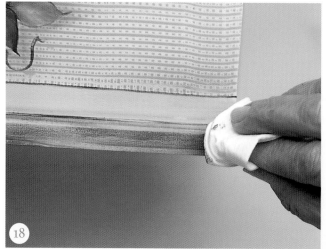

## HINT

1. *Don't use old contact paper and don't use a hair dryer. If you do, the gum on the back of the contact paper might stick to your surface. If you do get gum stuck to your surface, use a rubber cement pick-up tool to remove it.*

2. *It is always beautiful to add a touch of your flower color to the darkest shadow area of your leaves.*

# Completed Trunk

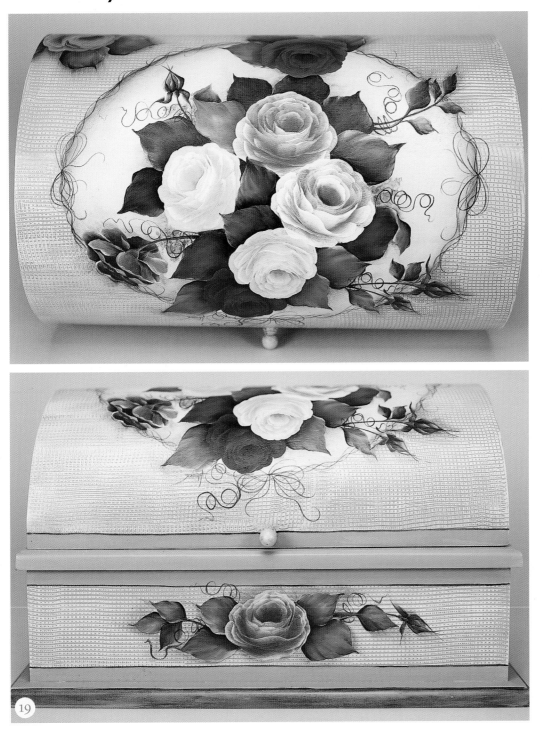

**STEP NINETEEN**

In order to finish the project, stripe the edges with thinned Payne's Gray using the no. 1 liner brush. The tray inside is painted Tapioca and trimmed with Ice Blue.

Fill your liner brush with a mixture of thinned Hauser Green Medium + Burnt Umber (1:1). Paint the curlicues. When the entire project has dried and cured, varnish with several coats of the water-based varnish of your choice.

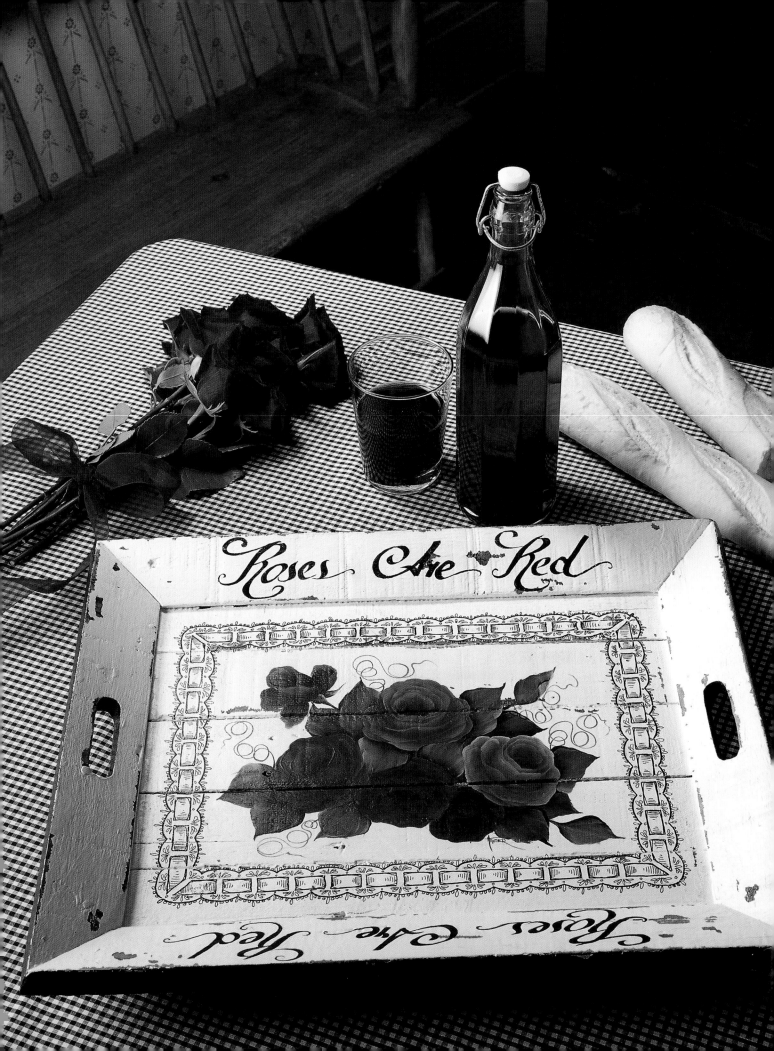

# ROSES ARE RED

There are so many surfaces to paint on! I found this old *vintage chic* tray at a garage sale. A large picture frame with slats of wood nailed to the back would work as well. In 1983 I had the privilege of presenting my red roses painted on a wooden panel to His Royal Highness, Prince Bernhard, of the Netherlands. The prince was president of the World Wildlife Fund International, and my painting was made into a greeting card to raise money for the foundation. My red roses represented the American Beauty rose.

These patterns may be hand-traced or photocopied for personal use only. Enlarge at 200% to bring them up to full size.

##  MATERIALS

**PAINT:** *(AP) = FolkArt Artists' Pigments; (A) = FolkArt Acrylics*

| BURNT CARMINE (AP) | BURNT UMBER (AP) | CLOVER (A) | HAUSER GREEN DARK (AP) | LICORICE (A) | NAPTHOL CRIMSON (AP) | POPPY RED (A) |

| PRUSSIAN BLUE (AP) | PURE ORANGE (AP) | RED LIGHT (AP) | TRUE BURGUNDY (AP) | WARM WHITE (AP) | WICKER WHITE (A) |

### SURFACE
- *vintage chic* tray from a garage sale

### BRUSHES: LOEW-CORNELL
- Series 7300 flat no. 14

### ADDITIONAL SUPPLIES
- Black Identipen by Sakura
- Clear acrylic spray
- FolkArt Blending Gel Medium
- Pencil
- Sandpaper
- Stain of your choice
- Stylus
- Water-based varnish
- White chalk or white graphite paper
- Wood chisel (optional)

## PREPARATION

You can create the *vintage chic* look:
1. Stain your wood piece (if it is unfinished) with the color stain of your choice. Let dry.
2. Apply two coats of Wicker White in a somewhat sloppy manner. Let dry.
3. Using heavy sandpaper, sand hard to remove paint here and there. You can even chip it off using a wood chisel, if desired.
4. Neatly trace and transfer your design.
5. For the pen and ink work, use a graphite pencil on the back of your traced design. Then transfer to the prepared surface. The ink will not flow well if you use graphite carbon. The ink may actually bead up on the carbon.

# Lace Border & Roses

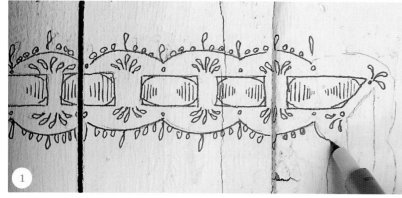

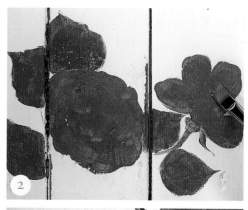

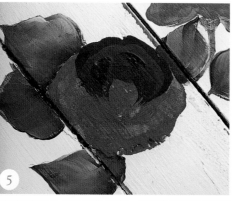

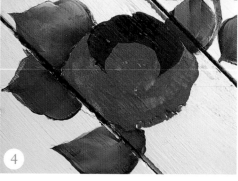

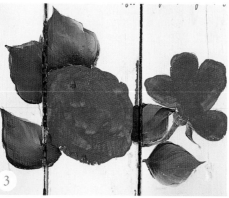

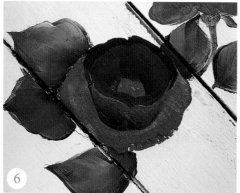

**STEP ONE**

Carefully ink the design. Let dry. Mist lightly with clear acrylic spray in a well ventilated area. If you do not do this, when you varnish later, the ink could run.

**STEP TWO**

Carefully undercoat the roses in Poppy Red and the leaves in Clover. Add a touch of Wicker White to the Clover for additional opacity.

**STEP THREE**

Paint the leaves. Instructions for painting leaves can be found on pages 31-34.

**STEP FOUR**

Double load your no. 14 flat brush with Napthol Crimson and a mix of True Burgundy + Burnt Carmine (1:1). Paint the first three strokes.

**STEP FIVE**

Wipe the brush and pick up more of the Red Light and paint the second row of petals.

**STEP SIX**

On this rose, strokes 8, 9 and 10 create a third row above the petals. (Yes, after you learn how to paint a rose, take artistic license and add as many rose petals as you wish.) Stroke 11 forms the first bowl. Stroke 12 forms the second bowl. Please notice I highlighted stroke 12 with a little Pure Orange on the Red Light side of the brush. Stroke 13 is a third bowl. I lightened the red edge with Warm White to create more contrast.

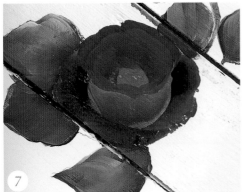

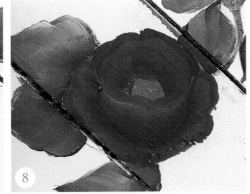

**STEP SEVEN**
Strokes 14, 15, 16, 17 and 18 are Napthol Crimson and the dark mix from step 4.

**STEP EIGHT**
Strokes 19, 20, 21, 22 and 23 will be Red Light and the dark mix.

**STEP NINE**
Paint one more row (strokes 24-28), and that should do it. Double load the brush with the darkest color and pick up a tiny bit of Warm White on top of the Red Light.

**STEP TEN**
Use the same color combination for the rolled S-stroke. Carefully fill the center using the darkest color on one side of the brush and the Red Light + Warm White on the other side of the brush.

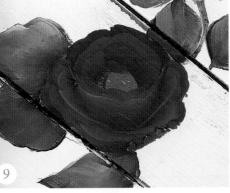

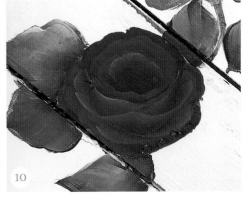

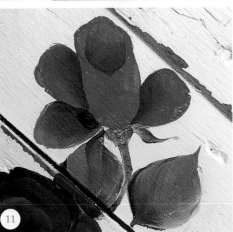

**STEP ELEVEN**
Begin the rosebud. Anchor the shadows with True Burgundy. Let dry and cure.

**STEP TWELVE**
Apply a little blending gel. Next, apply the colors: True Burgundy, Red Light, and a mix of Pure Orange + Warm White (1:1).

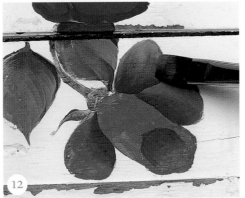

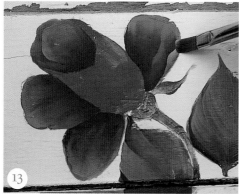

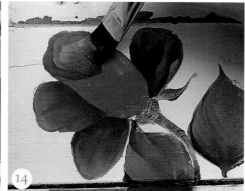

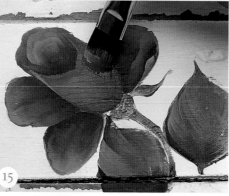

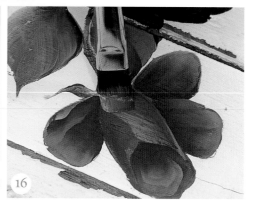

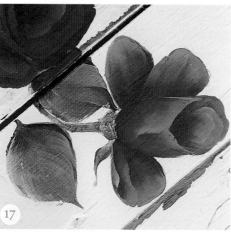

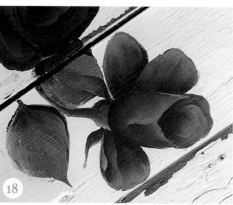

### STEP THIRTEEN

Blend, following the natural direction of the petal. To roll the edge of the petal, double load the brush with Red Light and the Pure Orange + Warm White mix (1:1). Paint the little S-strokes, as shown.

### STEP FOURTEEN

Create the center with a series of U-strokes. Double load your brush with True Burgundy and the Pure Orange + Warm White mix.

### STEP FIFTEEN

To create the base, make a *big* U-stroke. The dark mixture is on one side of the brush. Pick up just a touch of Warm White on the red side of the brush.

### STEP SIXTEEN

To create the separation, pick up more light color and paint a diagonal stroke, as shown. Touch up as needed.

### STEP SEVENTEEN

Paint the hips, calyx and stem with the greens as instructed on pages 40-41.

### STEP EIGHTEEN

The completed bud.

## HINT

*To achieve color similar to the color used here, go back to the same spot on your palette to blend every time.*

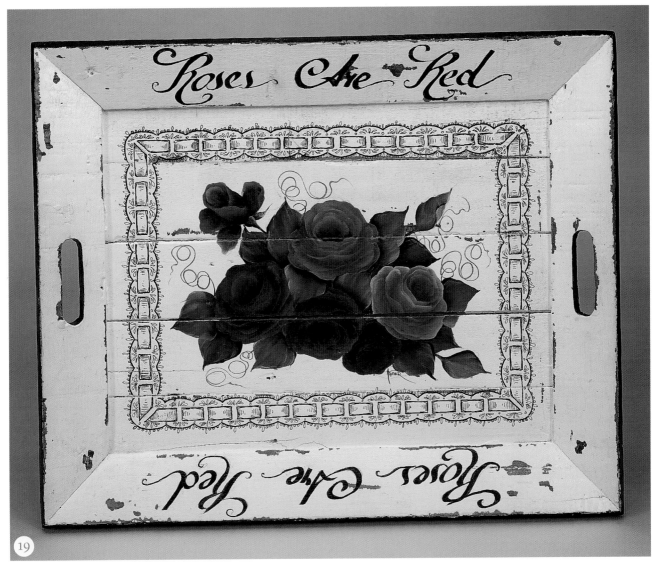

**STEP NINETEEN**

In order to finish the project, use your liner brush and thinned paint to create curlicues with a mixture of Hauser Green Dark and Burnt Umber (1:1). Paint the lettering with Licorice. Trim the edge with True Burgundy.

When dry and cured, varnish with two or more coats of the varnish of your choice. If desired, a piece of glass can be used over the design to create a more durable surface.

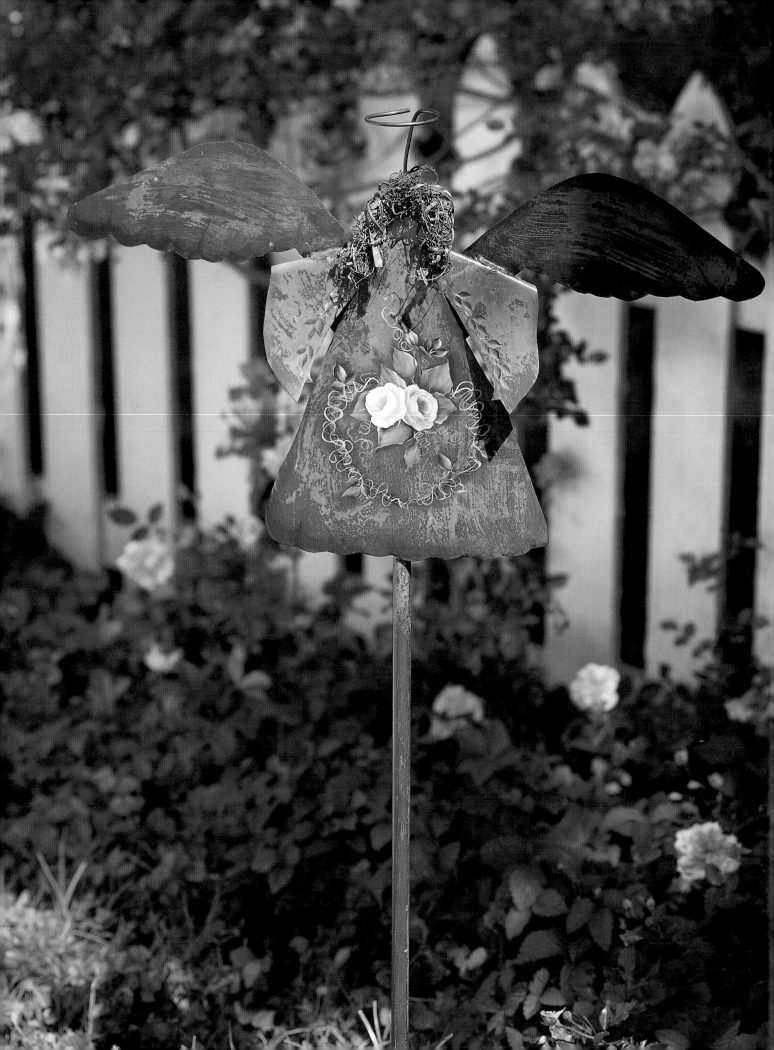

# GARDEN ANGEL

 Angels definitely live in gardens. I know my roses don't properly bloom without one. I found this copper angel in a garden shop. Even in the winter, when flowers aren't in bloom, my garden angel warmly displays her roses. I know the patina of the copper will become more beautiful with time.

# Pattern

This pattern may be hand-traced or photocopied for
personal use only. It is shown here full size.

## MATERIALS

*PAINT: (AP) = FolkArt Artists' Pigments; (A) = FolkArt Acrylics*

BURNT UMBER (AP)    CLOVER (A)    HAUSER GREEN DARK (AP)    HAUSER GREEN LIGHT (AP)    HAUSER GREEN MEDIUM (AP)

ICE BLUE (A)    PRUSSIAN BLUE (AP)    PURE MAGENTA (AP)    TITANIUM WHITE (AP)    WICKER WHITE (A)

### SURFACE
- Copper garden angel (found at local garden shops)

### BRUSHES: LOEW-CORNELL
- Series 7300
  flat no. 20
- Series 7350
  liner no. 1

### ADDITIONAL SUPPLIES
- FolkArt Glazing Medium
- Exterior polyurethane spray
- Stylus
- White chalk or white graphite paper

## PREPARATION

1. Whatever surface you choose, be sure your surface is clean.
2. Neatly trace and transfer the design. Because the surface is copper, I used white graphite paper instead of chalk.

# Leaves & Roses

**STEP ONE**

Undercoat the leaves with Clover and the roses with Wicker White. Two or three coats will be needed to cover. Let dry and cure.

To create the background color, double load the no. 20 flat brush with glazing medium on one side and Burnt Umber on the other. Blend on the palette to soften the color. Apply the background color around the outside edge of the rose, all the leaves, and the inside and outside edges of the heart.

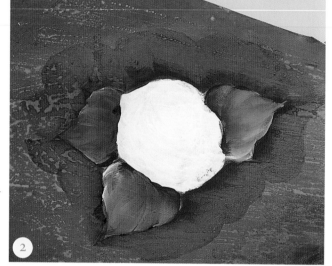

**STEP TWO**

For the dark leaf, use Hauser Green Dark, Ice Blue and a mix of Burnt Umber + Prussian Blue (3:1). For the medium-value leaves, use the dark mix, Hauser Green Medium, Ice Blue and Titanium White. For the light leaf, use the dark mix, Hauser Green Light, Titanium White + a tiny touch of Hauser Green Dark. Paint the leaves with these colors using the technique found on pages 31-34.

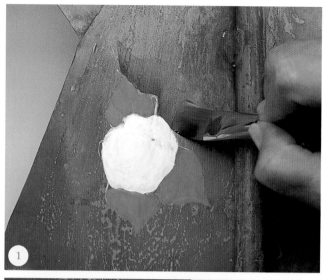

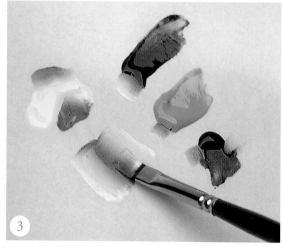

**STEP THREE**

In order to brush mix your colors for the white roses, stroke one side of the brush up against the edge of Titanium White, turn the brush over and stroke the other side of the brush through the Burnt Umber, then through the light green, and then with just a touch of Pure Magenta (all on the same side of the brush). Blend on the palette as shown in the photo until you have a silvery-taupe color. Don't try to match my color exactly—it will drive you crazy! A white rose can reflect any color or combinations of colors.

# HINT

*If the Clover color is too transparent, mix it with the Wicker White for more opacity.*

STEP FOUR
Paint the first three strokes.

STEP FIVE
Pick up more white and colors, if needed, and continue building the rose through the shell (first thirteen strokes). Before you begin the over-strokes, be sure you have enough shadow or darkness in the first thirteen strokes. Sometimes I refer to this as "depth of color." In this case, there should be more dark than light in these strokes because the next strokes need to show up as you stroke them over the darker strokes.

STEP SIX
Complete the rest of the strokes.

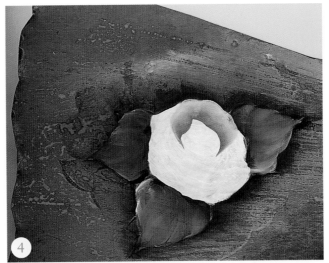

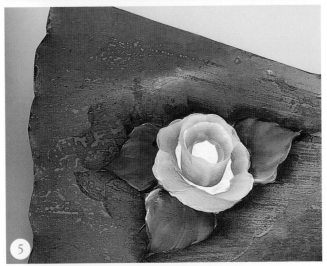

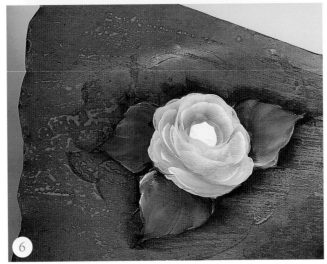

# Finishing Touches

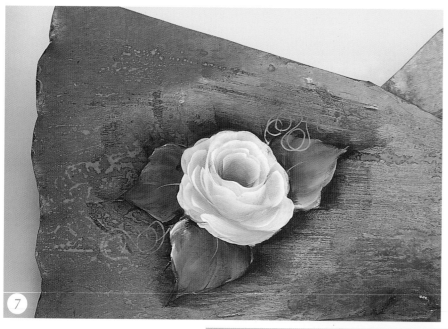

To finish the center, you may want to use a smaller brush. Apply the darkest color in the center of the flower and create the scallops (or quarter-circle strokes) to follow the upward curve of the flower.

7

## HINT

*If transparency is a problem (and it certainly can be) you can over-stroke any of the strokes after they dry. Just make sure you do this before you add additional petals. In other words, you cannot go back and stroke a petal that is underneath another petal.*

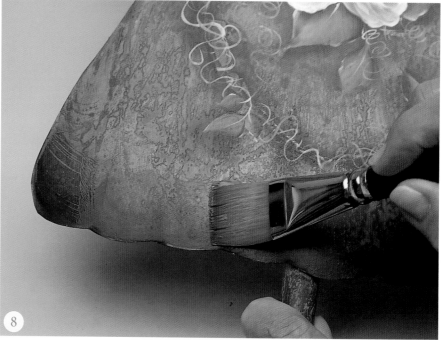

8

STEP EIGHT

Using your no. 20 flat brush double-loaded with Burnt Umber and glazing medium, float the Burnt Umber along the outside edges of the wings, sleeves and bottom of the skirt. Fill a liner brush with thinned Titanium White + a touch of Burnt Umber and add lots of curlicues. Thin veins of this color may be added to the leaves if desired.

# Completed Angel

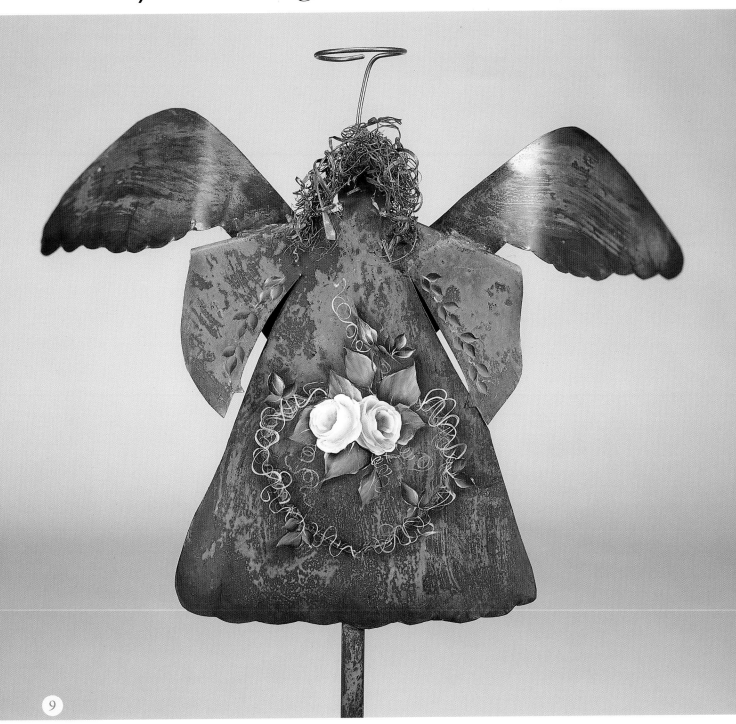

STEP NINE
Let the angel dry and cure. If she is to be used outside, I suggest varnishing with an exterior polyurethane spray. Be sure to spray in a well ventilated outside area.

# Resources

**LOEW-CORNELL**
563 Chestnut Ave.
Teaneck, NJ 07666-2490
(201) 836-7070
www.loew-cornell.com

**MASTERSON ART PRODUCTS**
P.O. Box 10775
Glendale, AZ 85318
(602) 263-6017
www.mastersonart.com

**PLAID ENTERPRISES, INC.**
P.O. Box 7600
Norcross, GA 30091-7600
(800) 842-4197
www.plaidonline.com

**VALHALLA DESIGNS**
P.O. Box 486
Glendale, OR 97442
(541) 832-3260
www.valhalladesigns.com

**WALNUT HOLLOW FARM, INC.**
1409 State Road 23
Dodgeville, WI 53533
(800) 950-5101
www.walnuthollow.com

# Index

**A**

Accessories, 77, 109
    *See also* Projects
Acrylic spray, 85-86, 104, 130
Acrylics, using, 10, 18, 21, 31, 53, 99
    (*see also* Paints)
Anchor, floating an, 10, 31, 35

**B**

Backgrounds, 10, 87, 104-105, 123, 138
Basecoating, 10, 12-13, 17, 86, 119-120
Bleed, paint, 18, 104
Blending, 10-11, 15, 21, 23, 33
    leaves, 36, 72-73
    palette, 43, 51, 87, 123, 132, 138
    petals, 54-55
    rosebuds, 131-132
    values for, proper, 53
Borders, 12, 74-75
Bows, 112, 123-124
    *See also* Curlicues; Ribbons; Streamers
Brushes, 14, 21
    liner, 11, 26, 55, 74, 125
    for projects, 63, 71, 79, 85, 97, 103, 111, 119, 129, 137
    tiny, 80
    *See also* Supplies
Brushstrokes, 10-11, 21
    circle, 24, 26, 28, 38, 44, 139
    comma, 10, 24, 28-29, 43-51
    flat, 24-26
    line, 24
    S-, 10, 25, 28-30, 33, 39-40, 47, 51, 131-132
    slice, 30, 50-51
    top, scalloped, 44
    U-, 25, 28-30, 38-40, 42, 45, 48, 73-74, 132
Burnishing, 10

**C**

Color
    depth of, explained, 139
    gradating, 15, 27, 39
Curing, 11
Curlicues, 74, 80, 90, 98-99, 106, 114, 125, 133, 139
    *See also* Bows; Ribbons; Streamers

**D**

Designs, transferring, 17-18, 79, 95, 103-104, 129
    *See also* Patterns
Details, adding, 41, 56-57
    *See also* Bows; Curlicues; Flowers, detail; Ribbons; Streamers

Dots, applying, 52, 64-67, 74
Double loading, 11, 21-22, 27-28
    backgrounds, 104, 123, 138
    brushes, tiny, 80
    calyx, 40
    leaves, 31-33, 35, 37, 88
    petals, 38, 55, 130-131
    rosebuds, 39, 73-74
    roses, 43, 52, 88-90, 122
    stems, 41

**F**

Fabric, 18, 91
    *See also* Mediums, textile; Projects
Floating, 10-11, 15, 22, 31
    shadows, 35, 37 (*see also* Shadows, creating)
Flowers, detail, 56-57, 64-67, 74

**G**

Glazing, 11, 15
Gold leafing, 10, 83, 85, 90-92
Gradation. *See* Color, gradating
Graphite paper, using, 17

**H**

Hair dryer, using a, 124
Heat setting, 18, 99
Highlights, 10, 22, 53
    bow, 124
    leaf, 34
    petal, 54, 130
    ribbon, 59
    stem, 41

**L**

Leaves, 31-37, 64-67, 72-73, 88-89, 122, 124, 138
    Basic Brushstroke Drybrush Blend, 31-34
    border, 37, 75
    gel, 37
    highlights on, 34
    shadows on, 72, 80, 88, 106, 122
    tiny, 80
    turned, 35-36
    undercoating, 31, 35, 64, 72-73, 87, 112, 138
    veins on, 34, 64, 140
Lettering, 128, 133

**M**

Mediums, 11, 15
blending gel, 10-11, 15, 18, 22-23, 32, 35, 37, 52, 112, 131
    crackle, 15, 85-86
    floating, 11, 15, 22
    glass and tile, 15
    glazing, 11, 15, 22, 37, 120-121
    textile, 95-98

Metal. *See* Projects; Surfaces, preparing
Miniatures, 77-81

**O**

Optivisor, using an, 41, 77
Outlining, 11, 37

**P**

Paints, 10, 13, 18, 21, 53, 99
    consistency of, 11, 21-23, 26, 34, 59
    lifted, avoiding, 112
Palettes, 12, 16, 21
Paper, 19, 103, 111
    matte-finished, 27
    preparing, 16, 111
    sealing, 15, 104, 106
Patterns, 10, 51
    for projects, 62, 70, 78, 84, 96, 102, 110, 118, 128, 136
    transferring, 12, 85-87, 120 (*see also* Designs, transferring)
Priming, 19, 63
Projects
    box, wooden, 69-75
    clock, wooden, 83-93
    dress form, silk, 95-99
    garden angel, copper, 135-141
    hat box, paper, 109-115
    invitation, wedding, 101-107
    miniatures, 77-81
    switch plate, wooden, 63-67
    tray, wooden, 127-133
    trunk, wood, 117-125

**R**

Ribbons, 58-59, 106, 112, 124, 128
    *See also* Bows; Curlicues; Streamers
Rose
    back view, 53-55
    basic, 38
    open, 43-52, 87-90, 98-99, 122-123, 138-140
    shell of the, 11, 43-48, 52, 139
    tiny, 80
    undercoating a, 52, 72, 87, 112
Rosebuds, 39-42, 73-74, 98, 131-132
Rose, parts of a
    base, 11, 30
    bracts, 42, 55
    calyx, 40, 132
    hips, 55, 132
    petals, 13, 29-30, 38, 50, 54-55, 73, 130-132
    stems, 41-42, 55, 114, 132
    thorns, 55
    *See also* Leaves

**S**

Shadows, 53
    floating, 10, 22, 31, 35, 37
    leaf, 72, 80, 88, 106, 122
    ribbon, 58
    rosebud, 131
Sizing, 11
Staining, 12, 15, 129
Streamers, 75, 124
    *See also* Bows; Curlicues; Ribbons
Striping, 12, 125
Stylus, using a, 12, 17, 64-66, 74
Supplies, basic, 12-15
    for projects, 63, 71, 79, 85, 97, 103, 111, 119, 129, 137
Surfaces, preparing
    copper, 137
    fabric, 18, 97
    metal, 19
    non-porous, 15
    paper, 19, 103, 111
    tole painting, 19
    wood, 17, 31, 63, 71, 85, 119-120, 129
    *See also* Basecoating; Projects

**T**

Techniques
    antiquing, 124
    crackling, 15, 83, 85-86
    finishing, 20
    flyspecking, 66
    glazing, 11, 15 (*see also* Mediums, glazing)
    shell of the rose, 11, 43-48, 52, 139
    wet-into-wet, 23, 51
    *See also* Anchor, floating an; Basecoating; Brushstrokes; Double loading; Floating; Gold leafing; Paint; Staining; Undercoating; Varnishing; Wash, color

**U**

Undercoating, 10-11, 13, 22
    leaves, 31, 35, 72, 112, 138
    ribbons, 58, 112
    roses, 52, 72, 87, 112, 138

**V**

Values, 11, 21, 53
Varnishing, 15, 20, 66, 75, 81, 93, 115, 125, 133, 141

**W**

Wash, color, 10-11, 57, 114
Washing, of surfaces, painted, 18, 99
Wood. *See* Projects; Surfaces, wood

# MORE GREAT INSTRUCTION FROM
## *North Light Books!*

Let Michelle Temares show you how to develop, draw, transfer and paint your own original designs for everything from furniture and decorative accessories to walls and interior décor. "Good" and "bad" examples illustrate each important lesson, while three step-by-step decorative painting projects help you make the leap from initial idea to completed composition!

ISBN 1-58180-263-3, paperback, 128 pages, #32128-K

Learn how to enhance your paintings with the classic elegance of decorative gold, silver and variegated accents. Rebecca Baer illustrates detailed gilding techniques with step-by-step photos and invaluable problem-solving advice. Perfect for your home or gift giving, there are 13 exciting projects in all, each one enhanced with lustrous leafing effects.

ISBN 1-58180-261-7, paperback, 144 pages, #32126-K

This book is the must-have one-stop reference for decorative painters, crafters, home decorators and do-it-your-selfers. It's packed with solutions to every painting challenge, including surface preparation, lettering, borders, faux finishes, strokework techniques and more! You'll also find five fun-to-paint projects designed to instruct, challenge and entertain you-no matter what your skill level.

ISBN 1-58180-062-2, paperback, 256 pages, #31803-K

This guide makes using color simple. Best of all, it's as fun as it is instructional, featuring ten step-by-step projects that illustrate color principles in action. As you paint your favorite subjects, you'll learn how to make color work for you. No second-guessing, no regrets-just great-looking paintings and a whole lot of pleasure.

ISBN 1-58180-048-7, paperback, 128 pages, #31796-K

**THESE BOOKS AND OTHER FINE NORTH LIGHT TITLES ARE AVAILABLE FROM YOUR LOCAL ART & CRAFT RETAILER, BOOKSTORE, ONLINE SUPPLIER OR BY CALLING 1-800-448-0915.**